BUSH NEGRO ART

An African Art in the Americas

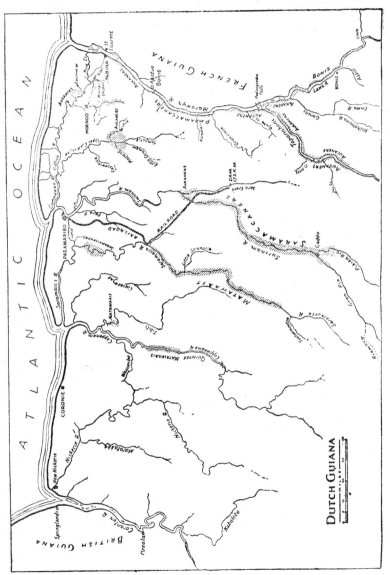

DUTCH GUIANA

Scale of Miles

(from KAHN, *Djuka* 1931
after a sketch by Bagelli)

BUSH NEGRO ART

An African Art in
the Americas

PHILIP J. C. DARK

1954
ALEC TIRANTI LTD.
72 CHARLOTTE STREET
LONDON, W.1.

Contents

Made and printed in the United Kingdom.

Studies of alien art forms should always be related to the culture in which they are found and an understanding of such forms can only be attained through an equal comprehension of the culture patterns of a society of which they are a part. Those who are interested in primitive art should therefore be acquainted with the discipline of anthropology as well as that of art. There has been a strong tendency to consider primitive arts in terms of Western European æsthetics and few studies have been made of the æsthetic systems of peoples with different traditions of art from our own.

The short study presented in the following pages attempts to give a description of the major aspects of both Bush Negro art and culture. It attempts to give the cultural setting of the major facets of the art, within the limits set, in the hope that its formal aspects are thus set in a wider configuration of culture patterns and do not stand alone without context to be admired only for themselves. It is hoped that the cultural divisions covered in this short summary may enrich the general picture, or, failing this, that they may promote a more extensive enquiry than has been possible here, and thus lead to a deeper understanding of Bush Negro art.

Bush Negro art is unique and offers a fascinating field of study. The core of its traditions lie in 17th and 18th century Africa. But it is a new art created in the New World and is incontestably Bush Negro. No other negro art form in the Americas, of which some African traditions survive, can claim the vitality, the lack of eclecticism and the freedom from other cultural influences of Bush Negro art. Further study, in the field, of this art is required so that information for comparative studies, with West African art forms, and for knowledge of the æsthetics of peoples with different art traditions to our own can be pursued. Only

when such studies have been made for these and other cultures can we begin to comprehend the æsthetic processes of the major arts of the world, for we are limited in the way we express ourselves verbally by our oral traditions, and in our other forms of expression by the thought patterns behind language. We are likewise limited by the motor habits acquired as members of the particular culture in which we are raised and educated.

ACKNOWLEDGEMENTS.

I am deeply obliged to the following institutions for the privilege of studying their collections and for permission to photograph specimens :—The American Museum of Natural History, New York, The University of Pennsylvania Museum, Philadelphia, and The Peabody Museum of Natural History, Yale University, New Haven. The first of these has also kindly given me permission to reproduce figures 8, 9, 18, 19, 20, 21, 23, 44, 49, 50, 51 and 52.

Dr. Morton C. Kahn has kindly granted permission for the reproduction of the map accompanying the text.

I wish to acknowledge particularly the same privileges, of studying and photographing the fine collection of Bush Negro art material, accorded me by Professor and Mrs. M. J. Herskovits. For their advice and their kindness, and that of Miss Bella Weitzner, of the American Museum of Natural History, in providing conditions for the easy handling of specimens I am most grateful.

My thanks are due to Professor Ralph Linton who first introduced me to Bush Negro art forms and encouraged me in my studies in primitive art. My gratitude is also due to Professor Wendell C. Bennett and Drs. Linton Satherthwaite and Irving Rouse.

Finally, I am indebted to my wife for painstaking assistance in the preparation of the manuscript.

On the north-east coast of S. America between French Guiana on the east and British Guiana on the west, is situated the Dutch Colony of Surinam, or Dutch Guiana. Occupying an area of some 46,060 square miles Surinam faces the Atlantic Ocean to the north. On the east its boundary with French Guiana is formed by the Marowyne River, with its tributary the Awa. On the west the boundary with British Guiana is formed by the River Corentyne for the whole of its course of about 250 miles. In the south the Tumuc Humac range of mountains forms the natural division between Brazil and Surinam.

Surinam can be divided geographically into four principal regions. The first region consists of a strip of alluvial land some three miles in depth from the shoreline which extends for about 240 miles in gentle curves. It is inhabited and cultivated. Moving inland from this first region the land slowly rises and becomes more hilly. In the second region the true forest is encountered. Here the rivers, often obstructed by rocks, intersect the forest. " In the river bottoms and swamps the soil is rich and the vegetation dense and varied, but it becomes much thinner on the higher slopes."[1] As one moves south in this region the forest thins out and the trees become less tall. Often there are open spaces with grass and flowering plants. Streams of all sizes intersect this region of sandstone, which possesses an abundance of springs. Passing from the third into the fourth region the savannahs are reached. Here trees become fewer and fewer as the area presents transitions from wooded to grassy country. Vegetation also becomes sparse after the lower levels are left behind. The undulating surface of this region is broken by isolated rocks.

There are five principal rivers in Surinam, all of which flow from south to north. These are the Corentyne, Cop-

pename, Saramacca, Surinam, and Marowyne or Maroni. These rivers provide virtually the only means of movement through the Colony.

The variety of the fauna and flora of Surinam is considerable. The rivers contain a number of different kinds of fish, including the vicious perai. Bird life is represented by a large number of orders. There is a wide variety of doves, curlews, ducks and plovers, many parrots and such as the Canje pheasant. Bush birds make good eating. As with the birds there is a wide variety of mammals. The cat family is represented by the jaguar, the puma or American lion, the Ocelot or labba tiger, the long-tailed tiger cat, the Hacka tiger and others ; the smaller these animals become the more ferocious they seem to be. Other animals found are such as the tapir or maipuri, the South American fox, the kinkajou, crab-dog sloths, armadillos, anteaters, oppossums or yawarris and Guinea pigs. In the open country are found red deer, called welbisiri, or wood deer. One of the best forms of bush meat is the puffy-cheeked labba. Monkeys range from the howling baboon and spider monkeys to the sackiwinkis and marmosets. Reptiles are represented by forms like the Caiman, a number of lizards and snakes. Of these last there are a number of poisonous ones. There are many forms of tree frogs and a common amphibium is the great toad or crapaud.

The vegetation of the sea-shore fringe is similar to that of all low shores of northern South America, consisting chiefly of courida, which is largely confined to the coasts. The lateral roots of the courida form a natural break-water, being well adapted to resist the force of the sea and to prevent the muddy shores from being washed away. Mangroves are abundant on the muddy swamps at the mouths of the rivers.

As one proceeds up the rivers, the vegetation becomes very mixed and the number of species large. Outstanding are the giant aroids, bignonias with their white and mauve flowers and odontodenia with their apricot coloured blooms. Of the

2

taller trees the most conspicuous is the silk cotton. "It is characterized by the huge spread of the whole of its almost horizontal branches, and by the pendant seed-pods which swing with the breeze from the several leafless branches and twigs."[1] There are a great variety and abundance of palms throughout the whole alluvial region. Up the rivers on the higher lands the forest varies according to the nature of the soil. Palms are generally absent in this region.

The climate of Surinam is remarkably uniform. The controlling factors are " its situation within the tropical zone close to the Equator, the steadiness and frequency of the winds, and the influence of the sea. The north-east trade winds blow for the greater part of the year, beginning in December and the south-east trades blow for a shorter period."[2] The temperature rarely rises above 80°F. in the shade or falls below 74°F. at night. The mean average temperature is about 80-81°F. The rainfall varies from 60-80" inland ; on the coast the mean exceeds 100". In the interior the wettest period is from January to July ; no single month, however, is really dry.

The population of Surinam consists of native Indians, European and Jewish settlers, Negroes, Asiatics, African and European mulattoes and a small sprinkling of fugitives from the penal settlement of French Guiana. Economically and numerically the Indians, the principal tribes of which being the Ojanas, Upuruis and Trios, are unimportant. In 1941 they numbered 2,616.[3]

The Negroes of Surinam are divided into two classes : first, those descended from the slaves who escaped into the forest when the Colony was handed over by the English to the Dutch in 1667. These, numbering some 19,032[3] today, are known as Boschnegers, Bush Negroes. Secondly there are the descendants of the slaves who continued after the emancipation in 1863 to live as free men in the towns and plantations. These, including mulattoes, number 70,415.[3]

The inhabitants of Surinam, save the Bush Negroes and Indians, live mainly on the narrow strip of seaboard. Of a total population of 183,730 about a third lives in the city of Paramaribo.

History.

Slaves were brought to Surinam from about 1650 on, or perhaps earlier. From 1650-1826 the average number of slaves brought annually into the Colony was between 1,500 and 2,000. Probably some 300,000 slaves in all entered Surinam and yet the total number of people today of African origin is only 89,447. Hiss suggests that the reasons for this lie in the facts that there was, and is, a preponderance of males over females, the Negro birth rate was low under the severe conditions of slavery, the infant mortality rate, always high, was higher under slavery and the death rate from disease was high.[4]

At the Peace of Breda, in 1667, Surinam was handed over by the British to the Dutch. The Peace of Westminster confirmed the Dutch possession of Surinam and the English settlers withdrew. A number of Negro slaves at this time escaped into the bush to form the nucleus of Negroes who, with additional refugees from the Dutch plantations over the next hundred years, are the ancestors of the proud and independent Bush Negroes living today in the jungles of Surinam. The struggle for survival in a most unfriendly environment and against the ruthless oppression of the 18th century, and the subsequent gaining of freedom and virtual independence, bear witness to the determination and vitality of these peoples. The course that this struggle took is paralleled by similar attempts elsewhere in the New World on the part of the enslaved Negroes to escape their enforced subservience and create free societies cast in an African mould. The Palmares Republic was the first major attempt made. However, its duration, though short lived, was a heroic defiance

4

against the Portuguese. It lasted from 1630-1697. Haiti, though late in attaining independence, is the outstanding example. But the Bush Negro obtained official recognition of their independence earlier than the Haitians, from about 1772 on, and are perhaps the foremost group of New World Negroes who have preserved in its purest form their racial identity with their African ancestors.

From the very beginning of the importation of slaves into Surinam, from the middle of the 17th century on, some slaves escaped into the bush. The threat of these to the planters did not crystallize till 1712 when Admiral Jacques Cassard, with thirty eight vessels and some three thousand men, raided and ransomed the Colony. Many plantation owners fled leaving their Negro slaves. These, after joining the French in plundering the estates, fled into the bush carrying off a number of weapons with them. Joining with those who had fled from time to time over the previous six decades, they raided outlying isolated plantations and seized more arms and ammunition. The stage was thus set for subsequent insurrections which led to the abandonment of outlying plantations, " continual losses from raids, and a paralysis of effort from fear."[5]

The first general slave insurrection occurred in 1730, on the government plantation at Bergen-Daal. Uprisings continued till the turn of the century. The results of these insurrections were to drive plantation owners into Paramaribo leaving their estates in charge of overseers. These treated the slaves abominably which resulted in " a vicious circle of killings and reprisals on both sides."[6]

Many Bush Negroes were executed as a result of the Bergen-Daal uprising but this, far from terrorizing them, brought the opposite effect. They remained a formidable foe and in-domitable. This led, in 1749, to the Goverment seeking peace with the Saramaccaners. In 1750 a present of arms and ammunition was sent to Captain Adoe, the chief of the rebels, but, unfortunately it was intercepted by a rival chief,

Zam Zam, who proceeded to massacre the whole party. Adoe thought he had been deceived by the Dutch so hostilities broke out again. The situation was further aggravated by an insurrection by another group of rebels, led by Chief Araby, at Tempaty Creek in 1757, and the Dutch sued for peace. A treaty resulted in 1761 at Ouca, being signed by Araby and sixteen of his captains. The accompanying oath, taken by both parties, consisted of drinking from a calabash in which each person had allowed a few drops of his blood to mingle with spring water and some particles of earth.

In the same year a second attempt was made to conclude hostilities with the Saramaccaners, but Zam Zam once again captured the party delivering the presents. However, no one was harmed and a treaty signed in 1762 finally concluded the matter.

The presents sent Captain Adoe of the Saramaccaners included a silver knobbed cane, having the arms of Surinam engraved on it. Today the silver knobbed cane is an acknowledgment of Dutch rule, the Government holding the right of appointing the paramount chiefs of the Bush Negroes. Adoe's acceptance of the cane, which at that time was considered a recognition of independence, was also an acknowledgment that independence was a prerogative of the Dutch Governor.

Peace did not last long. The Dutch evidently did not learn the lesson of the previous year's insecurity and war, for their treatment of slaves soon deteriorated. Stedman's remarkable narrative bears witness to the cruelties committed. These led to another outbreak of hostilities in 1773, on the Cottica river. To meet this threat the Dutch formed a regiment of slaves, known as Rangers. In return for fighting the rebels the Rangers were promised their freedom. A Scotts Brigade of twelve hundred men was sent out from home and, together with the Rangers, managed to put an end to organized resistance, but only after five years of the most arduous campaigning which left the Brigade decimated. Less

than a hundred men survived its rigours. The destruction of villages and provision grounds caused a number of the Bush Negro to cross into French territory, where they found refuge. These were the ancestors of the present Boni tribe.

No treaty resulted from the cessation of hostilities Though fighting did not occur again, as Hiss has pointed out, resentment was not eradicated.

Tribal Composition and Territory.

From the time of the cessation of hostilities between the Dutch and the Bush Negro, the latter settled down to a peaceful existence in the bush having only the arduous task of coping with an exacting environment. Today there are three principal tribes, the Saramaccaner, the Aucaner and the Boni, with three small tribes, the Matawaais, the Quintee Matawaais and the Paramaccaners. As can be seen from the accompanying map all these tribes, save the Boni, live along the banks of the principal rivers that run through the jungles of the interior of Surinam. The Bonis are mostly in French territory, living on the east bank of the Lawa river. The largest tribe is the Saramaccaner, which has twice as many members as the others. They live along the Surinam river and its tributaries " from Kabel station to the confluence of the Gran Rio and Pikien Rio."[7] The Aucaners live on the upper Commewijne, the Marowijne and Tapanahoni rivers. Each of the three smaller tribes numbers but a few hundreds. The Matawaais live " on the upper Saramacca river, the Quintee Matawaais on the middle Coppename river and its tributary the Tibiti river " ; the Paramaccaners, or Paramaccers, live " on the west shore and on some of the islands of the middle Marowijne river."[8]

The Aucaners used to be known as the Djukas. This word seems to have evolved from Ouca, which was the name of the plantation where peace was signed in 1761, and by which the group of signatories became known. The term Djuka is used

loosely by the town Negroes of Paramaribo to signify all Bush Negroes. As the Bush Negroes are looked upon by the town Negroes as being particularly skilled in the control of the supernatural the term Djuka may also be applied to a person who is not a Bush Negro but who is skilled in these practices.

Intercourse between tribes and transgression of tribal territory is rare. Intrusion is resented and the offender is thrashed severely, as a warning. The inter-tribal jealousy over territorial rights seems " to have originally arisen over lumber cutting and balata bleeding rights, as well as from the poaching of game and fish."[9] At one time there were inter-tribal wars.

Language.

There does not seem to be agreement by those who have written of the Bush Negro as to the language spoken by them. Kahn[10] says that the ordinary speech is *talkee-talkee* which is a mixture of Dutch, French, English, and Portuguese with some parts of speech deriving from West African dialects : it is also spoken by the town Negroes. Hiss[11] says that the Bush Negro speak a language known as the *Saramacca tongo,* which consists mainly of words African in origin. This is sometimes called *deepi-tahki.* Most songs are sung in this language and it is used in obeiah and voodoo ceremonies.

There is also a highly developed system of drum telegraphy. For this the Apinti drum is used. This is one of the three types of drums used by the Bush Negro for dancing. It is a tenor drum and has a carved foot on which it rests. The surface of the belly of the drum is decorated with intertwining curvilinear designs carved in low relief. The head of the drum is covered with a skin, held taut by means of pegs driven into the side.

Physical Characteristics.

Physically, the Bush Negro conform to the conventional West African type and show no signs of miscegenation. Marriage outside the tribe is forbidden. They are of medium stature, the average height of a man being five feet five or six inches, of a woman an inch or so less. Physically, they appear to be well developed, being very muscular and well proportioned. Physical deformity is evidently very rare. Kahn was impressed by their aristocratic bearing.[12]

Dress.

For the performance of their day to day tasks in the village, or on the river, the men wear a loin cloth of trade cotton. This is held in place with a string of twisted fibre which may either be plain or ornamented with beads or shells. For more formal and ceremonial occasions and for a dance a toga-like garment of coloured cotton patches is worn. The design formed by the bright patches is usually angular in nature. Herskovits reports having seen one where the stitching was worked into triangles and made to resemble the vertebrae of a snake.[13] The toga is draped over the right or left shoulder the other one being left bare.

The women wear a piece of bright coloured cloth, *pangi*, either draped entirely around the body above the breasts and hanging down to the knees, or tied below the breasts and hanging down somewhat further. In the more inaccessible villages only a small bit of cloth covering the vulva is worn. For ceremonial occasions the women substitute a white or light coloured material for the bright cloth of everyday use. The light coloured material is embroidered with designs in various colours.

9

Children of both sexes go naked until about ten years of age. The loin cloth of everyday use is assumed by the boys at about ten years old but the toga is not worn till after puberty has been reached.

Ornamentation.

Considerable attention is paid to dressing the hair. For this the Bush Negro use elaborately carved combs which are among the prized possessions of a woman. The combs vary considerably in size and decoration but basically conform to a rectangle in shape. Generally speaking half the length forms the tines, the other half, the handle, being carved with any one of a variety of designs. The decoration of the handle is usually in low relief with the motif being made to stand out by cutting certain areas right through, in full relief. The symbolism of the designs is often of a personal nature to the man, the donor, and the woman. The combs are not used as ornaments in the final coiffeur but only to dress the hair. To do this Kahn relates that the hair is first parted from ear to ear. A second parting is then made at right angles to this, from back to front. The four sections thus obtained are then subdivided as many times as possible. Each section so formed is then gathered up, braided or rolled and, where the length permits, tied at the ends with grass or fibre. The resulting plaits stick out from the head in small tufts, or hang loosely about the head.

Ornamentation is more common among the women but nearly everyone of both sexes wears a charm of one kind or another. The charms are for good luck in hunting, for safety and a variety of other needs. Both men and women wear bands fitted tightly just below the knee and the men also wear them about the biceps. This trait is evidently Arawak. The bands are about two inches wide and are of tightly woven cotton fibre. Both sexes wear bracelets in the form of wire coils, those common among the men being of heavy iron

10

wire. Some women's bracelets are coils of brass wire worn about the forearms and ankles.

Tattooing by embossing, or cicatrization, is common. The operation is performed with a knife and finely ground charred rice hulls are rubbed into the incisions made in the skin. The incisions, called *cutti-cutti,* or *Kamenba,* are made so that the resulting welts form angular designs, which are supposed to have erotic significance. The areas of the body that are tattooed are the forehead, cheeks or chin, the chest, back thighs and arms.

Government.

Most villages have a captain, who inherits his office in the matrilineal line. Selected from among the captains of the various villages by the Dutch Government is a chief who is elected paramount chief or *Gran Man* of the tribe. He holds office until his death and the captains are responsible to him for the government of their villages. However, according to Hiss, the role of the *Gran Man* and the captains is largely nominal. A dispute of a minor nature is settled by the captain. More important cases are settled by the *Basiea,* or Council, composed of the mature men of the village. As a matrilineal clan is dominant in one or more villages this council is probably made up, for the most part, of the heads of the extended families of the clan resident in the village. Traditional law is evidently largely African in origin.

It is interesting to note that the Dutch Government continues the practice, which was initiated at the various peace treaties made in the eighteenth century, of sending presents to each *Gran Man* every year.

Villages.

Villages " are situated on high ground near the banks of rivers."[14] They are often at the heads of rapids which, with

the placing of the provision grounds of many villages so that they are hidden from the river, is a vestige of the days of the slave insurrections. Virtually all movement is by water ; the rapids afforded natural fortifications.

The Bush Negro are expert rivermen. They make dugout canoes ranging from six to thirty-five to forty feet in length. The hulls are hollowed out from logs by means of fire and axes till the thickness is between a half and three-quarters of an inch. The bow, stern and thwarts are usually carved with decorative designs. Carved paddles are used to propel these canoes, though when going upstream the bowman uses a stout pole some ten feet long. The carved decoration of these paddles is restricted to the handle and the median section joining the handle with the blade ; the blade is usually left plain. The Aucaners are the only tribe who use paint as a means of decoration of paddles. They paint elaborate devices in three or four colours on the blades of their paddles, which are much wider and heavier than those of other tribes. The preferred colours are white, black, green and red and those used, judging from the specimens seen in museum collections, would seem to be paints obtained by trade from the Dutch. The designs are said to depict clan symbols.

The paddles of the Bush Negro are essentially like certain West African types and do not show any resemblance to Indian forms. Occasionally the handles of these paddles are similar to certain Arawak ones, but the influence of the Indian cultures in this respect are apparently very slight, as in most aspects of Bush Negro culture.

A path leads from the river to the village. Barring the entrance to the village is a barrier, *Azang,* of woven fronds. Every visitor wishing to enter the village must pass under this barrier which serves to ward off evil spirits and cleanse the person of any evil intent towards the villagers.

Bush Negro villages are clean and well kept. Most villages have a few community buildings, a council house, shrines for the various deities and for the ancestors, and a number of

dwelling huts. The huts are situated around the clearing but, apparently, are not arranged according to any special plan. The huts are rectangular with a ground plan of about seven by ten feet. They have four walls made of tightly woven grasses and leaves, and a thatched roof which hangs low at the sides. Wooden poles or hand hewn boards, usually lashed together with vines and lianas, though in some villages nails are used, form the uprights and sills. The wooden door posts and lintel are often finely decorated by carving which is sometimes enhanced by the addition of brass tacks and other decorative devices. The door, usually not more than four feet *Fig.* 52 high, may occasionally be carved and sometimes trick wooden locks are used, as in West Africa. The whole structure is weather tight.

Sometimes the huts are divided into two rooms by a woven mat which serves as a wall. The front room thus formed is used as a general living room and for cooking, the back room for sleeping. The man sleeps in a hammock woven of cotton or of grass ; the former is obtained by trade from the Indians. The wife sleeps directly below the husband on a mat woven of grass. Some villages have a cooking hut, consisting of a thatched roof on four uprights, which is used by several women from different families.

Household utensils consist of an iron pot in which all food is cooked, a flat slab for making cassava bread, a few wooden food paddles, a number of gourd utensils, one or two clothes beaters, and a tray or two. Each household will have a number of wooden stools for it is taboo to sit on the ground, some fans woven from grasses, which are copied from Indian work, some baskets and perhaps a wooden fire fan.

Nearly all wooden utensils are decorated by carving. They are gifts from the husband to the wife, not only as part of the bride price but as tokens of the affection of the husband for his spouse given her during courtship, and, from time to time, to maintain her affections.

13

The only objects carved by women are calabashes and, as a general rule, the women only decorate the interiors of these, and with designs of a style different to that of the men.

Food.

The staple food is the bread made from the bitter cassava. The Bush Negro have borrowed the Indian method of preparing this root suitable for eating. They use the Indian type of cassava squeezer. A variety of bush meat is hunted and shot : monkey, peccary, agouti, tapir, various rodents and birds ; these are preserved by smoking. If large game is shot such as tapir, it is divided among the community. Fish are also caught. Armadillos are not eaten as they are considered sacred. Peanuts, yams, peppers, maize, rice, and sugar cane are further articles of diet. Mareepa palm oil is much used and relished ; few persons set out on a long journey without a plentiful supply of this oil. Wild fruits and nuts are also garnered from the jungle.

Peanuts are pounded on finely carved boards with pounders. The handles of these are also carved. Carved trays are used for carrying and winnowing. Plates and cups are made from calabashes.

Most villages possess domestic fowl. The Bush Negro do not possess cattle or domestic swine.

The Bush Negro are expert hunters and fishermen. Most of them possess a shot gun but the bow and arrow is employed in both hunting and fishing. The bow is constructed according to the Indian pattern. Three types of metal pointed arrows are used for fishing : a plain arrow, a three-pronged one and a harpoon arrow. The arrow points are made from old knives by filing. Though fish poisoning is employed, poison is not used on arrows. Hook and line, nets, and a fish trap for capturing its quarry alive are also used.

Agricultural activities are conducted by both men and women, the former doing the heavier tasks of clearing the

ground for cultivation, the latter performing the lighter tasks of planting, attending the crops and harvesting. The soil, even after the slashing and burning, is not particularly fertile, " and the heavy rains leach out the mineral salts, further reducing its productiveness."[15] New provision grounds are cut next to the old ones making them highly susceptible to umbrella or leaf cutting ants. The Indians have observed that umbrella ants do not exist in virgin jungle ; they, therefore, always cut new provision grounds well removed from the old ones. The Bush Negro practice of clearing new fields each year next to the old ones means that after a certain period the grounds may be as far off as ten to fifteen kilometres from the village. Because of this, temporary huts are erected for the over-night shelter of those tending the fields. These somewhat reckless methods of agriculture, which make cultivation a more and more arduous task, are reminiscent of certain West African peoples.

Crafts.

The only weaving of fabrics done by the Bush Negro is the cotton leg and arm bands mentioned previously. The cotton cloth they wear is obtained by trade from the Dutch.

In basketry the weaving is generally simple and well executed. A number of different forms are represented in figs. *Figs. 46—48* 46 to 48. The circular baskets are used for carrying foodstuffs, such as yams and rice. They vary from less than a foot to three feet in diameter. Cassava squeezers, which are woven from uniform rattan, fans and cassava sifters are sometimes decorated with interwoven darker strips. The forms and techniques have evidently been borrowed largely from the Indians, though some items suggest possible African derivations.

The only pottery made by the Bush Negro is a solid black undecorated and somewhat crude ware. It is used for utilitarian purposes only.

The household, *wo su*, consists of the nuclear family : the mother and father and their children. If there are plural wives each wife has her own house. If a man can afford it he keeps his personal belongings in a special hut, *godo woso*. There is generally a store house for produce and shrines for the family gods.

Residence among both the Saramaccaner and Aucaner tribes may be patrilocal or matrilocal. Descent is matrilineal. Inheritance is matrilineal but as in many other societies where this is the rule the personal ties between a father and a child may cut across this and certain things may pass from a father to his child which do not normally follow this inheritance line.

The next largest unit to the household is the extended family. Among the Saramaccaners this is the *'bê*. It is an exogamous grouping. If endogamy occurs the group does not act against the offenders for it is believed that infraction of the rule will be punished by the gods. Group sanction of the couple only occurs after the gods have punished them with death. This sanction takes the form of withholding any form of ceremony to accompany the burial and this is considered a severe punishment for the offenders. Brother and sister incest is similarly punished. If a child is born of such a union it is exempt from any punishment.

Various personal food taboos are inherited from the father. Infraction of these taboos is believed to bring on skin infection ; persistent disregard of them will lead to leprosy. The significance of the relationship of the son with the father through the inheritance of food taboos is to be seen in the economic sphere. A man will place a fetish, *ka du*, over a house, at the mouth of a creek to guard fishing rights, in a field, and so on. For people not having the same food taboos, *kina*, or *tcina* (among the Aucaner : *trefu*), violation of such rights would be supernaturally punished.

Marriage may be arranged by the parents or stem from personal preference. The bride price consists of a few bits of cloth, some sugar, and a number of carved household implements. The man lavishes a great deal of care on the carving of these for the symbolism of the designs is often of great personal significance between the couple, who are thus bound with strong ties of sentiment. If a girl is not a virgin the bride price will be less. A husband finding out after marriage that his wife is not a virgin can inform the council of the tribe, who will rule the repayment of part of the bride price. Cross cousin marriage is permitted.

Gifts of carving, *sanneh* or *timbeh,* help maintain the affections of a woman for her husband, for divorce is apparently an informal matter. Great respect is paid parents-in-law by the spouses of their children and all relations between the two are characterized by the greatest constraint. Attitudes to a spouse's brothers and sisters depend on their relative ages. If they are older then they are accorded the respect paid a father- or mother-in-law ; if the brother- or sister-in-law is younger there is evidently a joking relationship. There is also a joking relationship between children and grand-parents or great aunts and uncles.

The levirate is compulsory. The junior levirate is the norm but failing a younger brother the senior levirate functions.

The largest unit of social organization within the tribe is the *lɔ*. This is a clan. Theoretically the *lɔ* is exogamous. In practice descent lines may not be traceable so that marriages occur between members of a *lɔ*. Such marriages are not regarded as a sin. " The *lɔ* is, apparently, more or less localized and one *lɔ* is dominant in one or more villages."[16] Some of the names of the *lɔ* are those of the plantations from which the majority of ancestors escaped.

Among the Saramaccaner tribe each *lɔ* has its clan head. The captain, or headman, of the village in which a *lɔ* is dominant must be a member of that *lɔ*.

Among the Aucaner tribe there are twelve *l*ɔ divided into two sections : the *Opo* clans and the *Bito* clans. The former live on the upper Marowyne river ; the chief of the tribe is always selected from this group of clans. In joint assemblies of the two sections the members of the *Opo* section have precedence over those belonging to the *Bito* group.

The Bush Negro evidently cling tenaciously to their own culture and avoid contact with the Whites whose civilization they fear will mean oblivion for them. They also still fear that the Whites will re-enslave them. Some contact between the Bush Negro and the Dutch is maintained where the villages are near the Dutch towns. Leaf tobacco, which they use as a form of snuff, and money are used to purchase various implements and cloth, but the further off into the interior one moves the less importance is attached to money and the greater the significance of leaf tobacco as a means of exchange.

Religion.[17]

The Bush Negro believe that not only are human beings animated by spirits but that " everything, every object in the external world, is the residence of a spirit." These are called *mama.*[18] Thus huts, canoes, paddles, fetishes, stones, drums and so on are all the repositories of spirits which are personal to the objects in question. They are structured into a supernatural hierarchy embracing a whole pantheon of gods and spirits.

Students of West African religious forms have identified a number of these. The principal contributing cultures seem to be Ashanti, Dahomean and Yoruban, with the first, perhaps, outstanding, as in respect to the major influences present in other forms of Bush Negro society. The principal omnipotent spirit is *Nyankompon,* the Sky God, who corresponds to the Ashanti *Nyame.* The next most important deities in the hierarchy are the Mother of the Earth and the Mother of the River, *Tone,* both of whom were created by *Nyame.* The

18

name of the Mother of the River, *Tone,* probably derives from the Ashanti *Tano,* a spirit occupying a position in Ashanti culture similar to that of *Tone* among the Bush Negroes. *Nyankompon,* in his role of universal originator, created man and animal and the dual aspects, good and evil. *Obia,* the good and healing spirit, helps man to overcome the evil spirits, which try to dominate him. Man is plagued by *Akantamasu,* the god of the ant hill, who also teaches humility. *Obia* and *Akantamasu* appear to be close to the Mother of the Earth and the Mother of the River in the supernatural hierarchy, though the positions occupied by other Bush Negro spirits is not clear from the literature. A number of important spirits are mentioned. *Dagowe,* the snake spirit, is close to the Earth Mother and the Mother of the River ; the Haitians and Dahomeans dance to the same spirit, called *Dangbe.* Snakes are particularly significant in the eyes of the Bush Negro. Their spirits are good and they should never be killed. If, however, a snake is killed by a person he is likely to die, for the spirit of the snake will have taken possession of his body and only the performance of sacrifices and rigid penance will save him. The whole village joins in a special ceremony to give a snake that has been accidentally killed an honourable burial. A snake entering a hut is never destroyed or forcibly removed but is " asked " to leave or shooed outside.

The position occupied by the ancestors in the world of spirits of the Bush Negro is not clear. The ghosts of the dead are known as *Winti,* or *Yorka* (a Carib word). If such a spirit enters the body of a person and causes him to behave abnormally it is known as a *Wissi,* an evil spirit. Some Bush Negroes claim that the ancestors ranked after the Earth and River mothers but higher than *Obia* ; others that their power was less than *Obia* who was effective against the *Yorka,* the ghosts of the dead.

Evidently ranking with *Tone,* the Mother of the River, are the *Apuku* gods, the gods of the bush, who seem to be mostly women's gods. One of these deities exemplifies the Bush

Negro conception that the union of the gods paralleled that of humans, for *Kientina Dagowe* was the son of *Dagowe,* the snake god, and another *Apuku* god called *Kentina.* The bush is the habitat of many spirits. Besides the *Winti,* or *Yorka,* and the evil version of these, the *Wissi,* there are the *Congo Burtri, Jumbees,* the *Bakru,* the *Azeman* and the *Cromanti.* The *Congo Burtri, Jumbees,* cause bad luck. The *Bakru* causes pain ; it is reported to be very ugly, appearing in the form of a monkey or a little mannikin with a large head. The *Azeman* are spirits who leave their skins at night to travel about in the form of ugly, bleeding, skinless persons. Particularly evil and wild is the *Cromanti* spirit. It may take the form of the tiger-jaguar or the buzzard. The behaviour of an individual possessed by such a spirit is usually imitative of that of the particular creature that has possessed the person. Thus in the assimilation of the living form of the spirit, a person when possessed by it, is a danger to those around, save to those of the *Cromanti* group, for he will lay around him with any weapon that comes to hand. When men are dancing to the *Cromanti* spirit the village elders are careful to keep objects that might cause harm out of the way. Villagers not of the *Cromanti* group take care to keep clear. Those of the *Cromanti* group are not harmed by one of their members under possession, for the group is protected by the wearing of a *Cromanti obia,* or charm. Such an *obia* has good qualities —as opposed to its association with evil elsewhere—but it only manifests them for those of the *Cromanti* group, for whom it offers protection, helps to heal and warns against danger. In West Africa one of the most dreaded secret societies is the Leopard Society. It may be that the Bush Negro fear of the *Cromanti* jaguar spirit is a transfer to this animal of the fear of the leopard held by their ancestors who were taken from West Africa as slaves. Those slaves that were shipped from the ports of Little and Great Coromantyne, on the Gold Coast, were the most war-like ; only the English and Dutch Colonists consented to buy them. It seems possible that the

Bush Negro *Cromanti* group is the survival of the African warrior society, though there is no evidence of the *Cromanti* groups in Surinam having anything of a military character about them. The *Cromanti* spirits live in silk-cotton trees. Silk-cotton trees are present in both West Africa and South America. They are sacred to most of the inhabitants of West Africa and to the peoples of Surinam, both Bush and Town Negro, and to the Indians. The Bush Negro refuse to touch this tree with a knife or axe, in fact they show great reverence to its spirit by making slight obeisance to one when passing it. It will, however, do no harm if left alone ; Vandercook remarks " No forest demon ever feels or shows active enmity toward men, unless it is first harassed."

Little reference is made to Indian spirits for the Bush Negro traditions maintain that their ancestors cleared the land, made the rivers navigable, and created the great forests.

The personal application of the spirit, *Obia*, to the needs of the people is as a preventive and curing agent. In each village there are generally two or three " *obia* priests " who provide people with charms, or *obias*, according to their particular requirements. These personal *obias* thus have various attributes, such as : for successful fishing, to prevent an illness sent by an enemy from lodging in the body, for keeping away ghosts, to watch over a person journeying on a river, etc. According to the nature or potential action of the particular charm and in order to obtain its benefits the wearer must observe the taboos associated with it. As well as the taboos associated with the wearing of an *obia* a person has to observe a variety of others. There appear to be three general categories of taboos, or *tehinas*. There are certain general taboos, such as against sitting on the ground, or harming an alligator, or a Bush Negro woman having intercourse with anyone outside her tribe, though this was not always so, anyway in the 18th century. An individual observes personal taboos and certain food taboos, which are inherited as well as acquired.

21

Death and *Kunu* are particularly significant in Bush Negro life. *Kunu* is a power or spirit which appears to be a force conceived to keep law and order in the society. If a man had been wronged and justice was not enforced, by committing some act he could bring the power of *Kunu* to bear on the party who had injured him and obtain retribution, for the action of *Kunu* leads to death. Crimes or offences that passed undetected by the society would not escape the scrutiny of the gods and ancestors. If they were angered by a particular offence the gods would mete out death, first to the offender and slowly to one member after another of the offender's kin.

Death, thus, may be due to *Kunu*. Alternatively, it may be due to the " black magic of a powerful enemy." There appears to be very little " natural " dying among the Bush Negro, save in a few cases of very old people. Before a person is buried it must be discovered what was the cause of his death and this knowledge the dead person must give. The cause of death is determined during the funeral ceremonies[19] by a custom that is almost identical to the " carrying the corpse " of the Ashanti.[20] The men who carry the coffin seem to be under some sort of trance. The party proceeds to the doorway of each hut in the village in turn and before each the *obia* priest asks the corpse : " Is this the house of the person who killed you ? " If the body rolls over towards the door of the hut, the answer is " Yes, this is the guilty one." If it rolls away the answer is " No, he is innocent." The person guilty in the olden days might have suffered the death penalty. A heavy fine or expulsion from the village seem to be the alternative penalties.

The actual burial takes place about seven days after the death of a person. Everything that is used in the ritual of death is taken away with the body. The corpse is carried around the village to enable the spirit to say goodbye ; to his kin, to the *Cromanti* society, if he were a member, and to the other villagers. The ties of each of these with the dead man

22

are symbolically severed by the slashing of a branch in two with a machete by the *obia* priest. The party then goes to the river bank where the coffin is embarked for the bush on the other side, in which the grave for the dead person has been prepared. Women are not allowed to accompany the dead person on this final leg of the journey to join the ancestors. Gun shots mark the arrival of the party at the opposite bank and at the grave side. A third shot announces that the body has been placed in the grave. A fourth shot announces the final ceremony of the placing of offerings beside the grave and the withdrawal of the burial party.

Formal mourning ceases after five months with a special ceremony performed on *Broko* day (breaking day). This ceremony is called *pai adyo*. Where the deceased was a man his oldest living brother provides food and rum for the elders of the village who gather about the widow's doorway. The woman stands inside the house and weeps as she scatters food for the dead and pours rum on the ground. Men and women dance in the clearing. Guns are fired to honour the dead. At dusk all repair to the river to bathe, and there the widow purifies herself by discarding her mourning clothes and putting on new ones and ornaments for the ceremony of rejoicing that takes place that night, when all the gods are danced to. However, the final mourning period is not over till seven months after the *adyo* ceremony, for a woman may not cohabit with her brother-in-law till this period has elapsed. If there is no brother-in-law then the woman has to wait twelve months after the ceremony before she can cohabit with a man.

This *adyo* ceremony seems to serve the purpose of anchoring the *dyo-dyo* soul of the dead man permanently to the body so that it will not wander about and harm the living ; the *dyo-dyo* is one of the two souls with which each individual is born, and is the " wandering soul " of a person. At death this soul returns to the body and the *adyo* ceremony evidently ensures that it will stay there. The other soul of a person is called *akra* (or *kra*) or *basuki*. This is his personal soul which, pro-

vided it is cared for, remains with him and guards him against evil. It can evidently leave the body, for if a person is not awakened with care the *akra* may not have time to get back into the body.

Drums are essential in communicating with the gods, in their worship and in singing and dancing. Drums are played to summon the spirits of the ancestors and then communicate their messages to the living. Messages to the living may also be conveyed through a person who has become possessed in the course of dancing to the drums. The possessed conveys the message by singing. Apparently a person may feel that his god wishes him to convey some message to the living and in consequence feels a restlessness. This prompts him first to wash and then daub himself with white clay, white being the colour of the ancestors. Each day of the week is sacred to a god so that the person waits for the special day of the particular god whom he feels wishes to communicate through him. On the auspicious day the person bedaubs himself with more white clay, and perhaps some of the participants in the ceremony too, and then prepares to go into a trance so that the god can speak through him. The rhythm of the drum helps bring on possession, though a rattle may suffice.

A battery of drums consists of three types: the *Apinti* (figures 40, 41, and 42a), the *Tumao* (figure 42c) and the *Agida*. The *Apinti* is the tenor drum and the most intricate rhythms are played on it. The *Tumao* gives the intermediate accompanying rhythms, and the *Agida,* the base drum, gives a steady beat which dominates the battery. Kahn mentions four types of drums: the *Apinti*, or signal drum, the *Nanda*, which is smaller than the *Apinti,* the *Baboula,* the smallest, and the *Ageedah*, which is sometimes six to eight feet long. The *Ageedah* is played with a hard stick about a foot long, the free hand being used to beat the more intricate rhythms. The other types of drums are played with the hands.

All drums give two tones, a higher note when played at the outer edge, and a lower one at the centre. A drum can be

tuned by adjusting the pegs driven into its trunk. The lashings holding the skin taut over the head pass round these pegs.

The *Apinti* and *Tumao,* when being played, are tilted at an angle, the player squatting on the instrument which rests on his heels. The basic rhythm is set by the base drum, the *Agida,* the *Kwakwa,* the *Saka-sake* and an improvised triangle. The *Kwakwa* is a low bench with a hardwood top which is beaten with two sticks by a player who squats beside it. The *Saka-sake* is a rattle made from a gourd filled with pebbles ; it is struck on the hand. Any two pieces of iron provide the triangle. Drums are only played by men.

The Bush Negro have a variety of dances. The *bandamba* is a dance for little girls of about eleven. The participant stands with the hands behind the head, keeping the feet stationary on the ground, and raises the buttocks up and down. In the *awasa* dance a man may simulate the flying of a hawk, another that of an eagle. Kahn[21] mentions a court-ship dance where coitus is imitated, the man following the dancing woman with a drum on which he beats out a message of love. In the *sacatee* dance are re-enacted events of the rebellions to the accompaniment of special songs. A dance to the *Apuku,* the gods of the bush, is accompanied with arm movements that simulate the twisted lianas of the jungle. The most furious is the *Cromanti* dance. The dancers, smeared on face and body in varying patterns with the sacred white clay that indicates the presence of a god, dance in a hysterical state of possession. They lay about them with the machetes they carry, in a most dangerous manner, or eat the earth, or bite wood, and so on. Others dance a sham battle, stalking an imaginary enemy then fencing with their knives ; sometimes the possession is so violent that two men slash at each other. Only complete physical exhaustion, causing the dancers to drop from fatigue, brings such a dance to an end.

Pemba dotee, the sacred white clay, is smeared on all reli-gious or ceremonial objects. Those present in Bush Negro shrines are covered liberally with it. An individual must be

smeared with it when communicating with the gods. It appears to be an agent that promotes communication between the soul and the deity.

Shrines are situated in the villages and along the rivers. Along the rivers a shrine generally consists of a tall pole with, usually, some objects such as shells, bottles or pieces of wood, and offerings of food and drink at the base of the pole. A man who goes out to hunt or fish will often pause to call the god and his ancestors to aid him in obtaining a good catch.

In the villages images are kept in little houses, or sheds, which are little more than roofs to keep off the rain. A wooden post, thickly smeared with *pemba dotee,* with an iron pot, or posts with cross pieces from which hang a length of white cloth, are usually present in most villages. At these shrines prayers for aid or thanks are offered to a god or the spirit of an ancestor. A petition is accompanied by the pouring of water or rum on the ground. Prayers are some-times said directly to *Nyankompon* or to an ancestor to intercede with *Nyankompon* for aid. It is not clear whether the images represent a person's ancestor or not. Herskovits gives the impression that they do and the pole type of shrine is to the Sky God or other gods. There do appear to be definite shrines to the ancestors, *Fa'aka Pau* houses, where the stools of the ancestors, whitened with the sacred *pemba dotee* and blackened with soot, are kept. There also appear to be specific shrines to the *Voodoo* and *Apuku* gods in small houses where covered whitened vessels are kept, as well as other objects.

Religious images are crudely executed in contrast to other objects made by the Bush Negro. The style of carving seems on the whole alien to that of the secular work. These provide one of the strange anomalies of the Bush Negro for so many patterns seem to have their origin in West African culture ; much of the Bush Negro religion seems to stem from West Africa, yet the religious carving is poor in comparison with other work.

Combs.

Figs.
1—8

Based on distinctions of gross forms there are four principal types of combs. These are : Rectangular, Trapezoidal, Rectangular Spheroid, and Trapezoidal Spheroid. The Trapezoidal form is the most common. Occasionally a type of comb with the form of a trapezoidal intercept is found. Sometimes a comb may bifurcate, or two combs may be linked with a wooden chain, the whole specimen being carved from one piece of wood.

Diag. I

The tines are nearly always round or rectangular. The panel separating the tines from the carved handle is nearly always decorated with hatching, which may be single stroked or crossed. Hatching may also appear as part of the decorative scheme of the handle. Brass tacks and cartridge marks often provide additional decoration, but the use of branding, as in the bifurcating specimen, is rare.

The common designs are variations on certain geometrical forms, such as eights, U's, V's, S's, points, and spheres. The depiction of animal forms, as in figures 1B and C, is rare. The motifs are usually carved by a combination of piercing, or full relief, and low relief, though some pieces have their designs created by only one of these methods.

As has been mentioned, combs are used only to dress the hair and not as part of the coiffeur. They also form part of the bride price and are significant as gifts of a personal nature from a man to a woman.

Food Paddles.

Figs.
9—17

Food paddles are of two types : those with a blade attached directly to the handle and those where a median section separates blade from handle.

Diag. II

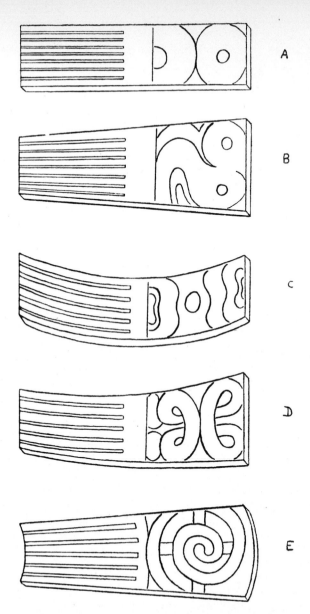

Diagram I. A. Rectangular. B. Trapezoidal.
C. Rectangular spheroid. D. Trapezoidal spheroid.
E. Trapezoidal intercept.

If food paddles are thought of as being carved from a rectangular piece of wood, by drawing an imaginary line from the edge of the blade to the edge of the handle they can be divided into the formal categories that characterized combs. These are : Rectangular, Trapezoidal, Rectangular Spheroidal and Trapezoidal intercept, the last two necessarily requiring an examination of the curvature of the longitudinal axis. Linked paddles and other variations are rare and represent *tours de forces* of the carvers.

Diagram II. A. Blade of food paddle attached directly to handle. B. Food paddle with median section between blade and handle.

The decorative devices of hatching, cartridge marks, etc., used for combs are also found on food paddles. Similarly the principal designs employed on the handles are variations on certain geometric forms. Groupings of certain of these are to be seen in figures 10 to 16.

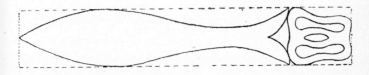

Diagram III. Food paddle carved from rectangular piece of wood.

Median sections are not usually as elaborately carved as the examples shown in figures 9C, and 17B and G ; for the functional aspect of the median part, that of providing strength between the handle and the blade, is usually taken into account in decorating this section. As can be seen from the

29

illustrations : spirals, rings, and a chain motif (a survival of the days of slavery) are found as median design elements, though when a median section is present it usually is little more than a section of the stem running into the blade, lightly decorated, so that its function is maintained.

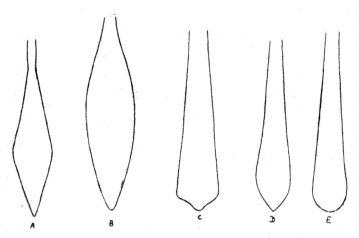

Diagram IV. Common outline forms of food paddle blades.

The outline form of the blades varies considerably. The commonest of these are shown in diagram IV. When decorated, blades are carved in low relief ; carving by piercing is rare. When designs are used to decorate the blades of paddles they not infrequently appear to belong to a set of motifs alien to those used on the handles. They would appear to be related to some system of signs of a symbolic nature personal to the donor and recipient. In this respect they suggest an affiliation with the system of writing reported for the Aucaner.

Considered from the same formal aspects as were food paddles clothes beaters have a handle and a blade with a median section joining the two. They can be divided, principally, on the basis of form, into Rectangular Spheroids and and Trapezoidal Spheroids ; a Rectangular Intercept form is sometimes found. The spheroid aspect of form would seem to be concomitant with the function of beating clothes. Their heaviness, obtained through greater thickness, is likewise functionally necessary.

Decorative devices are similar to those employed on combs and food paddles, though only the handle may be carved by piercing. However, the upper surface of the blades, which are carved in low relief, are generally decorated with motifs that relate to those employed on the handles ; the three examples shown in figures 17D, and 18A and C are somewhat exceptional. Some pieces show a fine consideration of the relationship of the decorative surfaces of the handle, median section and blade within a scheme of design for the whole beater.

Canoe Paddles.

Canoe paddles are very similar in many aspects to food paddles. They have a handle and a blade joined by a median section. They can be grouped on the basis of formal aspects similar to those considered for food paddles, combs and clothes beaters, though such a categorization requires a certain subjective element on the part of the observer. The formal categories that can be derived are Rectangular and Trapezoidal.

Decorative devices are similar to those mentioned for combs and food paddles. Unusual however is the use of paint on

Fig. 19 some paddles, which has been discussed previously,[22] otherwise the blades are generally plain ; occasionally they are carved like the blades of food paddles.

The designs used on both the median sections and the handles fall within the same range as those noted for food paddles, but the type of design employed seems to be limited to some extent by the function of the paddle. In this respect the form employed at the top of the handle is somewhat limited by the necessity of providing a suitable grip for the *Figs.* 21A 22A hand. Some handles have a crescental-shaped top, which is a design found on food paddles, but on canoe paddles the ends of the crescent are more distinctive, thus according with the function of gripping when paddling.

Figs. 23—29

Stools.

On the basis of the differences in the forms of their tops, *Diag.* V stools can be divided into six types :—(A) Long rectangular, (B) Squarish rectangular, (C) Crescental, (D) Circular, (E) Folding, (F) Hemisphere.

Diag. Va (A) The Long rectangular type of stool is composite. The two legs are always at right angles to the top and they may be joined with cross pieces. Some have straight tops, others curved ones. The edges of the top, or seat, may be plain or carved.

Diag. Vb (B) The Squarish rectangular type has similar features to type (A). The stools of this type, however, have generally only straight tops and do not have cross pieces between the legs. This latter feature accords with the squarer rectangular nature of the top which, not having a long overlap each side of the legs, does not require cross pieces to secure the legs as in type (A).

Diag. Vc (C) The Crescental type of stool, known as *libba bangi*, in contrast to the first two types, is carved from one piece of wood ; further, the legs are always parallel to the length of the top, which has smooth uncarved sides. The whole stool is

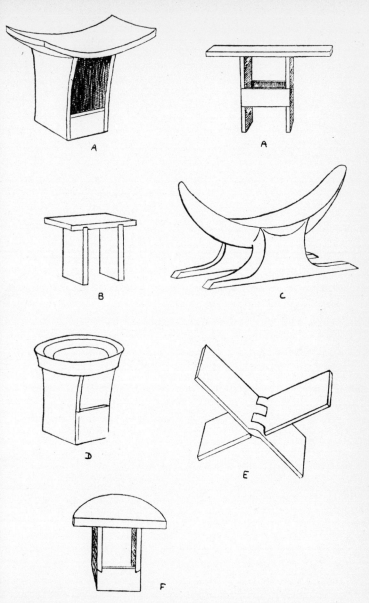

Diagram V. A. Long rectangular stool. B. Squarish rectangular stool. C. Crescental stool. D. Circular stool. E. Folding stool. F. Hemisphere stool.

much thicker and more solid than the first two types.

If the tops of these stools are examined from above the
Diag. VI crescental shapes will be found to be of two kinds, : (a) bulging
crescental-shaped top, (b) continuous crescental-shaped top.

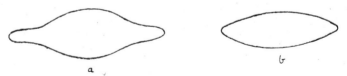

Diagram VI. *a. Bulging crescental stool.*
b. Continuous crescental stool.

This type of stool does not have cross pieces. The tops are
sometimes decorated with low relief carving but are never
carved by piercing. The legs are sometimes carved in this
latter fashion. The general shape of the legs is strongly
suggestive of Arawak influences, yet a certain subjective
quality recalls certain Ashanti carvings.

Diag. Vd (D) The Circular topped type of stool is composite. The
legs are always connected by cross pieces and sometimes these
fill the whole of the spaces in between. The tops of these
stools are relatively much thicker than those of types (A) and
(B) ; they are generally concave at the centre.

Diag. Ve (E) The Folding stool presents a good example of the
ingenuity of the Bush Negro carver for the two rectangular
sections that are hinged and form the stool are carved from
one piece of wood. When extended the ends forming the seat
are longer than those forming the legs.

This type of stool can be sub-divided into three types, based
Diag. VII on the nature of the hinges : (a) those with a 2,2 hinge, (b)
those with a 1,2 hinge, (c) those with a 2,3 hinge.

Diag. Vf (F) The Hemisphere type of stool, which is composite, has
a flat top and legs, which are at right angles to the diameter
of the hemisphere. Cross sections between the legs may or
may not be present.

Stools different from the types given above are rare.

34

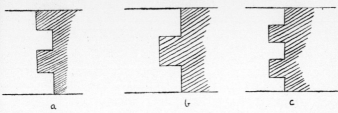

Diagram VII. *a. 2,2 hinge stool. b. 1,2 hinge stool. c. 2,3 hinge stool.*

In the composite types of stools, types (A), (B), (D), and (F), the tops, legs and cross pieces, if present, are carved separately and fitted together. The joining is sometimes accompanied by the use of nails to give additional stability, but in many pieces the joins are so exact that the fit is virtually perfect. In a few cases a wedge is let in through the top of the seat to the legs. In these cases the wedges are incorporated as part of the design of the seat.

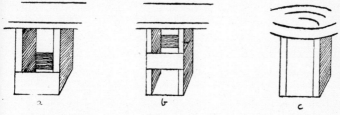

Diagram VIII. *a. Cross piece of stool flush with base of legs. b. Cross piece between base and top. c. Cross piece filling whole side.*

Where cross pieces are present on stools they may be (a) *Diag.* VIII flush with the base of the legs, (b) between the base and the top, and (c) flush with the base and filling the whole side.

There is a considerable range of variation of designs present on stools, as with other carved objects. The type of designs found are, however, very similar to those of such objects as combs and food paddles, though the size of the surface of a

stool that is decorated is obviously larger and consequently requires due consideration on the part of the carver. Though a motif is adjusted to the size of the surface this is not necessarily more elaborately decorated than are smaller objects. A surface that is carved by low relief or piercing, whether top, leg or cross piece, is always considered as a whole for decorative purposes. The design motif used on such a surface is nearly always a complete unit in itself. The carver, however, evidently bears in mind the motif used, for the designs decorating contiguous surfaces are usually related so that the decorative scheme of the whole stool is considered.

Sometimes only the top of a stool is decorated, sometimes the top and legs only and, at others, top, legs and cross pieces. The decorative carving may be piercing and low relief and varies from surface to surface in a stool, so that, for example, a stool may have its top decorated by piercing and its legs by low relief and its cross pieces left plain or enhanced only by some other decorative device.

As on other objects of Bush Negro carving, brass tacks, cartridge marks and hatching are used as forms of decorative elaboration. Inlay, whether of pieces of wood, a coin, or some other object, is also sometimes used on the tops of stools.

The surfaces decorated are only those that are seen when a stool is in ordinary use. The folding type of stool, for example, only has the sides forming the seat and the outsides of the legs decorated.

The more highly ornamented stools are evidently rarely used, serving as objects of admiration rather than utility and to exert any magic powers they may have acquired. Mention is made in the literature of certain stools having a clan emblem graven on the sides.

All trays made by the Bush Negro are round. They are always carved from one piece of wood, though there are examples where an addition, such as an extra rim, has been made to the main body of the tray. The rim of the tray is nearly always emphasized, demarking the interior surface for decoration.

Trays are of varying sizes. The range of diameter lengths would seem to be from fifteen to thirty inches. Some trays are carved in low relief only, others by piercing ; this forms a convenient means of classifying them. The former type can be sub-divided further into (a) those trays where the design on the back is different to that on the interior, and (b) those with plain backs. The latter, trays carved by piercing, have a different design on the back to that on the front. The design on the front, or interior, formed by piercing, may be elaborated by low relief carving ; elaboration of the pierced design on the back is rare.

Some trays are decorated with most elaborate designs and others relatively simple but there is in both cases an apt sense of the relationship of motif to the form decorated. The realization of the circular form of the tray is expressed by demarkation of the rim but never to the point or retraction from the design of the whole tray.

The designs used are largely different to those used on other objects, though a subjective quality relates them. Their difference is probably due to the requirements of designing in a circle. There is a close affinity between certain designs used and those employed to decorate the seats of the Circular top type of stool.

Brass tacks are often used in an elaborate enrichment of the interior of a tray. Hatching and cartridge marks are also sometimes employed as decorative devices but less frequently than brass tacks.

Peanut Pounding Boards.

Most peanut pounding boards have a plain rectangular surface on which the peanuts are crushed. The ends of the rectangle may extend and provide surfaces which are decorated by carving. A circular shaped board seems less common.

Some peanut pounding boards have legs which are parallel to the length, others have legs at right angles to the length ; some boards have no legs. The top of the board and legs are usually carved from one piece of wood.

The pounding surface slopes to the centre and either has a rim made by the addition of strips of wood or the edge is emphasized by low relief carving.

The decorative carving is usually both pierced and low relief in nature. The motifs employed are found on other objects. An interesting example of this is provided by specimen B in figure 37 and the stool in figure 29. As with trays and stools the decorative emphasis is on those surfaces seen most when the object is in use. This is enhanced sometimes by the use of brass tacks and hatching marks.

Figures 39B and C, show two examples of peanut pounders. They are $15\frac{1}{2}''$ and $11\frac{1}{2}''$ in total length and are made of a very hard wood.

Drums.

The use of drums and the part they play in Bush Negro culture have already been discussed in the section on religion. Here some of their formal aspects will be considered.

Based on form, drums are of two types : (a) plain cylindrical, (b) carved with base. The former type has a diameter at the head which is greater than that of the foot ; the sides are always plain. The *Agida* type is of this formal category, and probably the *Tumao* as well. In type (b) the diameter of the

38

base of the body of the drum is larger than that of the head. Projecting below the base is a carved foot on which the drum rests. The surface of the body of the drum is always decorated in low relief. The *Apinti,* and, probably, *Baboula* and *Nandi* types are of this formal category.

Both types of drum are hollowed out from one piece of wood ; the interior is left rough and only the outside surface shows finish.

A skin is stretched over the head of both types and pulled down the sides by a cord or cords. The cord encircles the skin, passing through it at intervals and down to wooden pegs that are driven into the side of the drum at an approximate angle of forty-five degrees. The tension on the skin can be increased by driving the pegs further into the walls of the drum, and thus the instrument can be tuned.

The designs carved in low relief on drums of type (b) frequently appear to be variations on a snake motif. Sometimes the design, starting at a given point, meanders round the drum with continuing variation, till it reaches the starting point, as though it was conceived on a flat surface which is then rolled into a cylinder. Other designs are continuous around the drum though if the cylinder is divided vertically into three equal sections the motif repeats itself in each.

Cartridge marks and brass tacks are sometimes used to provide additional decoration.

Calabashes.[23]

Figs. 49—51

On the basis of form, calabashes can be roughly divided into hemispheres and spherical intercepts. On the basis of *Diag.* IX surface, some calabashes are carved in low relief with designs on the outside, the inside being left plain ; others are carved by incision on the inside only. Calabashes decorated on the outside only are cut with the stem join at the top of the hemisphere. Those with designs on the inside only are cut longitudinally.

Those calabashes which are decorated on the outside are carved by men. The motifs employed are found on other objects of Bush Negro carving.[24] The surface around a motif is generally elaborately stippled. The design never overflows the rim, which is clearly marked. Calabashes decorated on

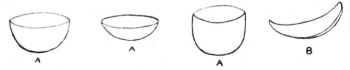

Diagram IX. A. Hemisphere forms of calabashes.
B. Spherical intercept form of calabash.

the inside only are carved by women. The designs employed are of a different style to that of the men, being more angular in nature. They manifest also a strong feeling for the segmentation of individual elements and a strong tendency to flow over into space, as in Maori "full rococo" carving. There is also a tendency to asymmetry which is not manifest in the men's work.

Calabashes are used as cups or small bowls. The spherical intercept form serves as a plate or a spoon.

A small section of a calabash in the shape of a cylinder, having the outside surface decorated, is sometimes used as a rest for a calabash bowl.

Fig. 46

Fans.

Fans are either made from wood or from plant fibres. The latter are probably made from the unexpanded leaves of the astrocargum, or from split itirite.

Three types of plaited fans have been seen by the writer. One type has a similar form to the two shown in figure 46, save the weave continues into the two ends of the handle forming more of a cross. These two types are exactly the same as Arawak fans.[25] A third type has a longish handle

with more rounded sides and resembles certain African forms ; coloured fibres were used to give additional decoration in the example seen.

Religious Images.

Figs. 43—45

Two types of religious images, based on formal differences, will be discussed here. The first type is represented by an image, which is carved out of one piece of wood, and has signs of paint on it, a charm about its neck, and a strong rectangular quality. This rectangular quality derives from the line of the arms, which if continued in space, as with food paddles or combs, meet the edge of the legs, and strongly suggest the image was carved from a rectangular length of wood of relative flatness. This piece is in distinct contrast to the second type where the roundness of a log of wood is exploited.

The second type is represented by an image with a single head and face, by one with a single head and two faces, one on each side of the head, and a third which has a single head and face, but in addition the body has very conventionalized arms and hands attached to it. All three examples have the head, neck and trunk clearly differentiated and these are carved from one single log of wood.

In the first two examples of this second type, a brown stain is used to demark the area and the central line of the face, and to decorate crudely the trunk of the image with circles or vertical lines. Strands of raffia are stuck in the ears, and sometimes tied around the neck ; occasionally they are to be found in a hole at the bottom of the face, which is evidently indicative of a mouth. Small cowrie shells let into the face serve as eyes. The neck and trunk are quite cylindrical. The profiles of the faces of both examples show a slight projection of the forehead and a gentle slope, in from the perpendicular and down, of the central line of the head. In front view, the planes of the face recede gradually to the outer edges, which are delineated by the brown stain line.

41

In the third example the head, which has no additional forms of decoration, save cowrie shells for eyes, is conceived differently. The planes around the eyes are circular, receding inward from the cylindrical form of the head to the central point of the eye socket. This means that the central line of the face is not differentiated as in the other two types, save by the proximity of the eyes. The trunk of this image is not straight as with the two previous specimens but is curved somewhat so that the figure leans forward. The arms of this image were attached to the trunk by a nail. The cylindrical form of the trunk has a section cut out to receive the arms. The two trapezoidal forms at the top of the arms each have a sawn off galvanized nail that lets in to each curved section, resulting in conventionalized hands. Cartridge marks provide a decorative pattern that enhances the curves of the arm forms.

The quality of the carving and the approach to the problems of form and decoration of these images seem alien to the rest of Bush Negro art. The images have not the æsthetic appeal of other carvings and give the impression that they are not conceived as forms of artistic expression but are purely utilitarian in intent. In this respect they are actually meant to be depositories for *obia,* the spirit which acts to prevent harm from other spirits, or for a god or a spirit or as a temporary locus for a spirit.

Art—Some General Considerations.

In the preceding pages a number of objects of Bush Negro art have been considered. These give some idea of the range of Bush Negro carving, the variety of designs employed and the virtuosity of the artists. Nearly all objects of wood are decorated with carved designs. The doors of houses, the door posts and lintels are generally elaborately carved. Doors often have carved wooden locks which show great ingenuity on the part of the carver who, as will be mentioned later, is very limited as to the tools he has to work with. Other trick pieces that have been mentioned, such as two combs linked by a wooden chain and carved from one piece of wood, are further testaments of the ability of the Bush Negro as a carver.

Materials.

The Surinam jungle offers a great variety of woods.[26] According to Kahn[27] lignum vitæ is sometimes used. Some pieces are carved from imported American white woods, but such pieces are made by those Bush Negroes living near the towns and are intended for the purposes of trade. These pieces are crude compared with those that are made in the interior. Information on the types of wood used by the Bush Negro is unfortunately lacking.

Tools.

The tools of the carver are limited to a machete and a small kitchen knife. The former is used for " felling trees, hollowing out trunks of massive logs for his dugouts, clearing the jungle, building his house, cutting his nails and picking his teeth."[28] A nail and a piece of string are used to plan the often complicated designs with which the carvings are decora-

ted. A highly polished surface is obtained by the use of sand as an abrasive. To create a darkened surface palm oil together with smoking is employed.

The equipment of most artists is limited to the use of the above tools and techniques. A few, favoured by their position in society and their economic status, do possess a much wider range of tools, obtained from Paramaribo by trade. Objects made by carvers with the limited equipment do not seem to be any less fine than those made by the few who have a wider range of tools.

Technique of Carving.

Because of the wide use of abrasives it is not easy to determine the technique of carving. An examination of hatching marks gives an indication of the conceptual approach of the carver to his medium. It would appear that a vertical

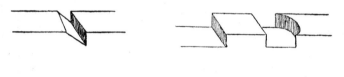

Diagram X. Carving by means of a vertical cut followed by a diagonal one.

Diagram XI. Removal of wood to produce a form in low relief.

Diag. X cut is made followed by a diagonal one up to the first. Designs decorating unpierced surfaces are formed initially in *Diag.* XI this manner. Subsequent cutting removes the wood to produce *Fig.* 1ᴀ a form in low relief. The handle of specimen A in figure 1 shows the former approach ; the lower parts of this comb show the motifs in low relief and full relief.

The Bush Negro artist seems particularly at home when dealing with the problems of low relief, full relief and piercing. Most objects carved are basically flat. When the problems

44

of carving in the round arise the artist seems to balk at a satisfactory conclusion. This is noticeable in the carving of the obeiah images which do not show any satisfactory solution to these problems. In fact these images show the same type of approach as that employed on objects that are basically flat forms. However, it may be that the purpose for which obeiah images are intended does not demand an æsthetic solution.

Decorative Devices.

Carvings are enhanced by a number of decorative devices. Brass tacks are sometimes used in profusion on a form so that they tend to retract from the significance of a motif in low relief. Generally, however, they are employed to give an additional emphasis to a design. In this latter respect they may be placed in a variety of ways. They may emphasize the flow of a form by being placed within it, as in diagram XII. *Diag.* XII

Diagram XII. *Brass tacks* **emphasizing the flow of a** *form.*

Diagram XIII. *Brass tacks alternating with cartridge marks.*

In this type of emphasis they may alternate with cartridge *Diag.* XIII marks. A form may be stressed by having brass tacks placed *Diag.* XIV around it. A part of a form may be enhanced by their addition, externally or internally. *Diags.* XV, XVI

Marks made by impressing the heated open end of an empty cartridge on the wood may decorate carvings in a manner similar to that achieved by the use of brass tacks. However, such marks are not used to emphasize a form by being placed outside it, as with brass tacks.

Inlay and colour are rare features of Bush Negro art. In most cases of the former the inlaid object forms an integral part of the whole design. Mention has already been made of the use of colour on Aucaner paddles.

Designs and Designing.

An examination of the illustrations should indicate the cunningness of the carver in varying the designs employed. In spite of this range of variation a feeling for the similarity of motifs from object to object is engendered. Basically the

Diag. XIV. Brass tacks around a form to emphasize it.

Diagram XVA,B. Part, or parts, of a form emphasized by addition of brass tacks externally.

designs employed are of a curvilinear geometric nature and, generally speaking, are such as eights, S's, or U's, scrolls and varieties of curves, which the artist varies slightly or combines differently in different objects. Further apparent variation is created by a motif, such as a hemisphere, being carved in low relief in one specimen, but appearing on the next by virtue of full relief carving, or having only a small section carved by piercing external to the motif.

The type of decoration employed on a surface is to some extent determined by its shape, though certain motifs are found common to a variety of objects. They tend to vary, nevertheless, to accord to some extent to the dictates of the shape they decorate. The shape of a circle as a design space seems to set definite limits on the type of motif employed.

The designs used on trays are mostly different to those used on other objects. This is also the case with those stools that have circular tops. Some designs used are common to trays and these stools. The affinity with designs employed on other objects tends to be at a subjective level.

Diagram XVIA,B. Part, or parts, of a form emphasized by addition of brass tacks internally.

The carver approaches the problem of designing on a cylindrical surface in two ways. Either the cylinder is conceived as cut vertically and rolled out flat, or thought of as a continuous circular surface. In the former case the design is symmetrical only at each end, i.e., when, as a cylinder, an imaginary vertical line separates the two symmetrical ends of a design that is continuous around the cylinder. In the latter case the cylindrical surface may be carved with a continuous meandering design or it may be divided vertically into three or four sections in each of which a motif, which is continuous, repeats itself.[29]

In composite objects, such as stools, each surface is considered as a whole for the purposes of decoration. Rarely does one design motif cover several surfaces. Though each is decorated as a unit, when an object consists of several surfaces the carver decorates each with motifs that are related in feeling. This gives the complete object the appearance of a unit not only in its final form but in the general overall decorative scheme. The surface that is generally most elaborately decorated is that which is most visible when an object is in a position of use.

Symbolism.

It would appear that most Bush Negro carvings have symbolic associations with sex. Most carvings although of utilitarian value are also carved as love tokens, *sanni* or *timbeh*, by the men for the women. Some pieces, however, are so intricately carved that they lose all utilitarian value and are only significant in an æsthetic and symbolic context.

The symbolism of the designs employed in Bush Negro carving varies considerably from artist to artist. Without the assistance of the Bush Negro themselves it is impossible to ascertain their significance. In fact it is reported that the symbolic content of the designs is frequently such that it is impossible for a Bush Negro, other than the artist, to decipher their meaning. "The same motif will be differently interpreted by different natives, and often has no objective meaning."[30] The obtaining of the meanings of the various designs is evidently made more difficult by the " natives having an engaging way of evading the questions of the investigator when appealed to for the meanings of the carvings. Some of this evasion may be traced to the African's love of strategy though in the main, there is a more direct factor. These carvings given to the women by the men have a sex symbolism which dominates most of the art, and since this symbolism is related to the concept of fertility not alone of the women, but also of the fields and the forest and the game animals which inhabit it, it is dangerous to offend the spirits by speaking too freely of these matters."[31]

Formal analysis of a number of specimens points to two different systems of symbols. The first of these consists of those motifs which are used to decorate such as the handles of combs or food paddles, clothes beaters and so on, in fact the general range of designs used in decorative carving. For example, an obvious snake motif appears on a number of objects ; and the chain motif, *moni moro muye*, is evident on

a number of pieces, particularly the median sections of canoe and food paddles. This latter refers to links of the iron chains of the slave days. In the second system of symbols there are a number of motifs which appear somewhat alien to those of the first. These appear either haphazardly placed on the surface of an object or as though they were afterthoughts to the total decorative scheme. It seems possible that this second system of symbols is concerned with the relationships, primarily of a sexual nature, personal to a man and a woman. On the other hand the motifs comprising the first system may have a symbolic content of a broader nature and be concerned with culturally patterned notions of fertility and sex common to all, though personal interpretations may be made or meanings of a personal nature be attached to the symbols. The two systems are not entirely separate entities for there are motifs, such as the vulva, common to both, though there would seem to be stylistic differences between the two. Perhaps the system of phonograms developed by the Aucaner is akin to this second system of symbols.[32]

There is a strong tendency among those who write about primitive art, and particularly primitive symbolism, to attach descriptive terms deriving from their own culture to designs and motifs they observe, thus often giving the reader a false impression that such terms carry the meanings attached to them by the people themselves. It should be made clear that for the business of formal analysis of alien art forms such terms are purely tools for the purpose of analysis. The recognition of a design such as a snake, a bird, a part of the body and so on by an observer does not necessarily mean that the particular design in question represents that form for the members of a particular culture. In primitive art styles of varying degrees of naturalism forms meaning the same for two different cultures may be more frequently met with. Where art styles tend to the geometric the symbolism may be completely obscure and falsely interpreted if categories of Western European art traditions are applied to them. The Bush Negro

exemplify well this obscurity, for the symbolism is not patterned for all members of the society and frequently is only meaningful to two individuals, the donor and the recipient of a carving. Further, it might be pointed out that no language can be exactly translated into another so that there are always subjective qualities that do not carry over when symbols are similar for two different cultures.

Closely related to the sexual symbolism impregnating Bush Negro carvings is the sentiment attached to many pieces by the women. To maintain the affections of his spouse the man woos her with gifts of carvings, for marital relationships in this culture show a certain lack of permanence. With divorce a somewhat informal matter the husband, wishing stability in his married life, finds himself in the position of a permanent suitor.

Sex Division.

Arising from the position of the woman as the recipient of carvings and the man as executor is the division of the field of æsthetics in Bush Negro culture. The women are evidently highly gifted connoisseurs of the art of carving and appreciate a new piece that is excellently executed. All men are in the position of creators and much of their sexual relationships is dependent on their ability as artists. The esteem in which a skilful carver is held is high. How far this affects the artist's position in the prestige series of the society is not clear, though a man's prestige rating would seem to be dependent for the most part on his position in the social structure. A good carver, however, is clearly in a strong position to influence the opposite sex and may well influence the course of events in his community. A man who is a poor carver is at somewhat of a disadvantage in respect to his relationships with women. Such a man, however, might be an excellent fisherman, or hunter, and thus be in the position to acquire better carvings than he himself can make by offering in exchange the products of the hunt, or his catch.

There is one important exception to the division of the men as artists and the women as connoisseurs and this is in the carving of calabashes. As has been mentioned previously these are carved by both men and women but the men, as a rule, only carve the outsides whereas the women only decorate the interiors. Certain other formal differences were noted but from an æsthetic point of view perhaps the most significant difference lies in the choice of designs for the purpose of decoration. The men employ designs which are of the same style as those they use to decorate other objects. The women's style, on the other hand, is alien to this. This difference parallels, or perhaps reflects, the general division of the æsthetic field, on a sex basis, into that of the creator and that of the connoisseur.[33]

Origins.

A number of factors have contributed to the formation of Bush Negro art. Of those contributing to its stylistic qualities perhaps Bush Negro art owes most to its African traditions. However, as these people are African in origin it has been the tendency to emphasize the influences of African art in the formation of Bush Negro art. The contributions made by the indigenous cultures of South America are generally accorded as being few and the subject has been somewhat neglected.

A number of material cultural traits have been taken over piecemeal from the Indians by the Bush Negro. Some of these are such as the cotton armlets and anklets, the bow and arrow, the cassava squeezer and various other forms of basketry. In the more specific aspects of art the forms of some stools and peanut pounding boards have clearly been copied by the Bush Negro from Indian work. Folding stools found through the Llanos de Barinas and Guarico of Venezuela are similar to Bush Negro forms, though identical forms of folding stools are found in Africa as far away as Tanganyika. Petroglyph

designs are found in the Guianas that are highly suggestive of some designs employed by the Bush Negro in their carvings. There are a number of other traits that could be cited and Linblom[34] discusses some of these, as well as African traits.

Apart from the facets of African culture which have contributed to the formation of Bush Negro society, many of which have retained their African forms today, there are many specific items of Bush Negro art which can be identified as African in origin. Most striking of these are drums, not only in form but in construction, and in the form of pegging for tuning the skin stretched over the drum head. Some seats are similar to those found in West Africa. Carved wooden locks like those of the Bush Negro are found in West Africa and in the Sudan. The use of brass tacks and cartridge marks is widespread in Africa. Many other items could be listed and many suggestions of affinities are to be found in the works of such as Linblom, van Panhuys, Kahn and Herskovits. The main problem, however, is the difficulty of assigning a specific trait to a specific provenance in West Africa. Some Bush Negro intertwined eight designs are very similar to those found on Benin bronze work. Other designs are similar to those found on Nupe brass trays. A photograph of some contemporary Yoruban ivory combs in the possession of the writer, at first glance looks like a photograph of Bush Negro combs. Perhaps it might be tentatively suggested that the Ashanti, Dahomeans and Yorubans contributed most to Bush Negro art. All in all the contributions made by the various provenances of Africa are not separable. It is clear that many traits were contributed from that continent and much of the subjective feeling engendered by Bush Negro art recalls African work. Further, Bush Negro art owes most to its African origins.

One aspect of Bush Negro art that has evidently been entirely neglected to date is the part that may have been played in its formation by English and Dutch art, particularly that of cabinet and furniture making. How far the slaves of the Colonists were familiar with these crafts, or with objects

of them, is not known. Certain scroll motifs in Bush Negro work may have been derived from European traditions. Similarly, other designs suggest affinities with the Celtic tradition, elements of which may have appeared on objects transported from Europe to the Colony, and also with Italian strap work.

With contributions from South America, Africa and, probably, Europe the Bush Negro has evolved an art form which is unique in style and possesses a vitality of its own. Bush Negro art is also one of the few " primitive " arts that has been virtually untouched by the recent rapid diffusion of European art traditions, and continues to pursue vigorously its own paths of expression.

COMMENT ON SOURCES CONSULTED.

The principal sources relied on for the sections from " The Setting " to " Villages " have been Hiss and Kahn. The Foreign Office handbook was referred to for data on " The Setting " and " History," and of course Stedman for " History." For the section on the " Social Organisation " Herskovits' account was the principal source used. Herskovits and Kahn provided the background of the section on " Religion " and their work gave useful information on Bush Negro art.

Short Bibliography.

Covarrubias, Miguel :
 Los Djukas : Bush Negroes " de la Guayana Holandesa," **Afro-**
 america, Vol. II, No. 3, pp. 121, 122, Mexico, Enero de 1946.

Dark, Philip J. C. :
 Bush Negro Art, M.S., Yale University, 1950.
 *Some Notes on the Carving of Calabashes from the Bush Negro of
 Surinam,* MAN, May, 1951.

Great Britain. Foreign Office. Historical Section :
 Dutch Guiana. Handbooks prepared under the direction of the
 Historical Section of the Foreign Office.—No. 136. In Peace
 Handbooks, Vol. 21, North, Central and South America : Atlantic
 Islands. London : H.M. Stationery Office, 1920.

Herskovits, M. J. :
 The Social Organization of the Bush Negroes of Surinam, pro-
 ceedings of the INTERNATIONAL CONGRESS OF AMERICANISTS,
 p. 713, 1930.

Herskovits, Melville J. and Frances S. :
 Bush Negro Art. THE ARTS. Vol. 17, No. 1, October 1930.
 Rebel Destiny. New York : Whittlesey House, 1934.
 Surinam Folk-lore. Columbia University contributions to Anthro-
 pology, Vol. 27, New York, 1936.

Hiss, Philip Hanson :
 Netherlands America. The Dutch Territories in the West. Duell,
 Sloan and Pearce, New York, 1943.
 *A selective guide to the English Literature on the Netherlands West
 Indies with a supplement on British Guiana,* Booklets of the
 Netherlands Information Bureau No. 9, New York : The Nether-
 lands Information Bureau, 1943.

Kahn, Morton C. :
 The Bush Negroes of Dutch Guiana. Journal of the AMERICAN
 MUSEUM OF NATURAL HISTORY, Vol. 28, p. 243—, 1928.
 Notes on the Saramaccaner Bush Negroes of Dutch Guiana.
 AMERICAN ANTHROPOLOGIST, Vol. 31, p. 468—, 1929.
 Djuka. The Bush Negroes of Dutch Guiana. The Viking Press,
 New York, 1931.
 Art of the Dutch Guiana Bush Negroes. Journal of the AMERICAN
 MUSEUM OF NATURAL HISTORY, March—April, 1931.

Lindblom, Gerhard:
Africanische Relikte und Indianische Entlehnungen in der Kultur der Bush Neger Surinams. Kung I, Vetenkapsoch Vitterhets-Samhalles Handlinger. Fjarde Foljden 28, pl, 1924.
Einige Details in der Ornamentik der Bush Neger Surinams. Riksmuseets Etnografiska Avdeling, Stockholm, 1926.

Ramos, Arthur:
Las Culturas Negras en el Nuevo Mundo, Fondo de Cultura Económica, Mexico, 1943.

Roth, Walter E.:
An Introductory Study of the Arts, Crafts, and Customs of the Guiana Indians. 38th Annual Report of the BUREAU OF AMERICAN ETHNOLOGY, 1916-17, Washington, 1924.
Additional Studies of the Arts, Crafts, and Customs of the Guiana Indians—with special reference to those of Southern British Guiana. Smithsonian Institution, BUREAU OF AMERICAN ETHNOLOGY, Bulletin 91 ; Washington, 1929.

Stedman, Capt. J. G.:
Narrative of a Five Years' Expedition Against the Revolted Negroes of Surinam, in Guiana . . . etc. London: Printed for J. Johnson, 1796.

Vandercook, John W.:
Tom Tom, New York, 1926.

van Panhuys, L. C.:
About the Ornamentation in Use by Savage Tribes in Dutch Guiana and its Meaning. Proceedings of the INTERNATIONAL CONGRESS OF AMERICANISTS, p. 209—, 1902.
Boschnegers, Encyclopaedie van Nederlandsch West Indies, The Hague, 1914—17.
Proceedings of the INTERNATIONAL CONGRESS OF AMERICANISTS, p. 426—, 1926.
Ornaments of the Bush Negroes in Dutch Guiana. Proceedings of the INTERNATIONAL CONGRESS OF AMERICANISTS, p. 728—, 1930.

FOOTNOTES.

1 Great Britain (1920 : 2).
2 *Ibid* : 4.
3 Official figures of the Surinam Government for December 31st, 1941 : Hiss (1943 : 190).
4 *Ibid* : 108.
5 *Ibid* : 81.
6 *Ibid* : 82.
7 *Ibid* : 32.
8 *Ibid* : 32.
9 Kahn (1929 : 474).
10 *Ibid* : 487.
11 Hiss (1943 : 36).
12 Kahn (1929 : 469).
13 Herskovits (1934 : 186).
14 Kahn (1929 : 476).
15 Hiss (1943 : 35).
16 Herskovits (1930 : 720).
17 A systematic account of Bush Negro religion is lacking from the literature. The reader will, however, find interesting data in Herskovits (1934) and Kahn (1931). Bush Negro religion finds virtually no expression in the plastic arts. Religion and æsthetic expression would seem to meet, rather, in the dance.
18 Kahn (1931 : 139).
19 Funeral practices, particularly, bear close resemblances to those of certain African peoples.
20 Rattray *Religion and Art in Ashanti,* Chp. XV : " Carrying the Corpse," p.167—.
21 Kahn (1931 : 58).
22 Cf., under section : " Villages."
23 For a fuller consideration : Dark (1951).
24 Compare figures 49A and 52.
25 Roth (1924).
26 Great Britain (1920 : 50—54).
27 Kahn (1931 : 196).
28 Herskovits (October 1930).
29 Cf., section on Drums.
30 Kahn (1931 : 198).
31 Herskovits (October 1930).
32 Kahn (1931 : 205—207).
33 Dark (1951).
34 Lindblom (1924).

DESCRIPTIVE NOTES TO PLATES.

All objects are of wood unless stated otherwise. Measurements are approximate. The villages from which specimens originate are not noted. Collections are abbreviated in the following manner : (AMNH) —American Museum of Natural History, New York, mostly collected by Dr. Morton C. Kahn ; (H)—Herskovits' collection ; (YALE)— Peabody Museum of Natural History, Yale University ; (PENN)— University Museum, University of Pennsylvania.

1. COMBS. (AMNH). The bifurcating type, A, is rare ; the dark marks are brandings ; compare designs on panels with figure 10. B is one of the finest specimens seen by the writer ; the top left hand corner would appear to have been broken off. The animal forms depicted in B and C are not frequent. All three specimens are from the Aucaner tribe. A and C are from the Tapanohoni river region. Lengths: A, 15¼″ ; B, 19¼″ ; C, 13¼″.

2. COMBS. (AMNH). A is from the Boni tribe middle Marowyni river region. B is from the Saramaccaner tribe. C and D are from the Aucaner tribe, C from the Tapanohoni river, D from the Sara Creek district. D is 11½″ long.

3. COMBS. (AMNH). B and C are carved from one piece of wood and are unusual specimens, " trick " pieces. The tops of B are branded. Compare with G, figure 8, and H, figure 14 ; compare panel design with B, figure 33. C consists of four interlocking combs, each section being 8¾″ long. D is from the Tapanohoni river region of the Aucaner tribe. A, B and C are from the Saramaccaner tribe, upper Surinam river region, B and C being collected from the same village.

4. COMBS. (AMNH). A is from the lower Saramacca river region of the Boni tribe. B to E are from the Saramaccaner tribe, B and E coming from the upper Surinam region. E is 13½″ long.

5. COMBS. (AMNH). There is a panel let into the hollow back of C, and in the interior is an object which rattles when the comb is shaken. Note the button let into the handle which may serve some magical purpose. The handle of D moves from side to side ; the boss can be seen in the centre of the panel. Note the motifs on the handles of A and D which are probably representations of the vulva. A and B are from the Saramaccaner tribe. C is from the Aucaner tribe, lower Marowyni river. D is from the lower Saramaccaner river. E is from the upper Surinam river region. D is 12¾″ long.

6. COMBS. (H). The handles of D and E are unusual for combs, the former being more like some median sections of food paddles. Note the small head at the top of the handle of E, a very rare feature. All specimens come from the Saramaccaner tribe with the reservation that C, E and G are not confirmed. A is 8" in length, C, 15" and F, 16¾".

7. COMBS AND FOOD PADDLES. (H). F is an unusual specimen, recalling E, figure 6. The top of the handle of comb E suggests an affinity with the top of stool B, in figure 23. The provenance of the combs and food paddles in this plate is not known.

8. COMBS. (AMNH). The plate conveys amply the magnificent designs and decoration of these two combs. B should be compared with the comb E in figure 8 to show similar approaches to form but with differing decorative schemes. A comes from the upper Surinam river region of the Saramaccaner tribe. B comes from the Sara Creek district of the Aucaner tribe. The former is 17" long, and the latter 20½".

9. FOOD PADDLES. (AMNH). In A, the opposite end to the blade may be a comb or fork. Pieces combining such double functions are rare. C is an unusual specimen and the delicacy of the decoration bears witness to the great skill of the Bush Negro carver, with his very limited tools. The carving of a food paddle blade, in the manner of this specimen, is very rare. Compare E and G of figure 17 and the unusual median section with B of the same plate. B is of brown heart wood. A and C are from the same village in the Sara Creek district of the Aucaner tribe. B is from the upper Surinam river region of the Saramaccaner tribe. A is 20¾" long, B 22¾", and C 21½".

10. FOOD PADDLES. (AMNH). A and C were carved by a boy of eleven years. A, B and C are from the upper Surinam region of the Saramaccaner tribe. D to H, and M and N are from the Aucaner tribe. E, F, and K are from the same village on the middle Marowyni river, and J, M and N from a different village in the same region. D, I, and L are from the same village on the upper Cormotibo river. G is from the Tapanohoni river region and H from the Rikenau Creek area. O is from the Paramacca tribe, Marowyni river. G is 17¼" long, and N 9¾".

11. FOOD PADDLES. (AMNH). C and D have black paint on the handles, a very rare feature. A, B, C, E, F, G, and I to N are from the Saramaccaner tribe, upper Surinam river region. H is from the lower Saramacca region. B and F are from the same village, A and G the same village, and I and J the same village.

O is from the Boni tribe, middle Marowyni river. B is $18\frac{1}{2}''$ long, and C 25".

12. FOOD PADDLES. (AMNH). A to E, G and M are from the Saramaccaner tribe. H, I, K, L and N are from the Aucaner tribe, I and K being from the same village on the middle Marowyni river, and L and N from the same village on the lower Marowyni river. H is from the Sara Creek district. F and P are from the lower Saramaccaner river region, O from the upper Surinam river region. J is from the Boni tribe, Lawa river. G is $23\frac{1}{4}''$ long, and O 18" long.

13. FOOD PADDLES. (AMNH). A, C to H, K to O are from the upper Surinam river region of the Saramaccaner tribe, save that D is not confirmed. A, F, and M are from the same village. B and J are from the Aucaner tribe, J being from the upper Coromotibo river region. G is $23\frac{3}{4}''$ long, and O $17\frac{1}{2}''$.

14. FOOD PADDLES. (AMNH). A, B and G are from the middle Marowyni river region, A being from the Aucaner tribe, and B and G coming from the same village of the Boni tribe. C, D, H to N are from the Saramaccaner tribe. C, H to M are from the the upper Surinam river region. L and M come from the same village. F is from Dutch Guiana ; it is $17\frac{3}{4}''$ long. N is $18\frac{1}{2}''$ long.

15. FOOD PADDLES. (AMNH). A to L are from the Saramaccaner tribe and all save J, of which the region of origin is not known, come from the upper Surinam river. A and D come from the same village ; B, E to H, and L originate from the same village, as also do D and K. C is $20\frac{3}{4}''$ long, and G is $18\frac{3}{4}''$.

16. FOOD PADDLES. (AMNH). A, B, D, F to L, N to P are from the Saramaccaner tribe ; all of these, save O, come from the region of the upper Surinam river. B and G are from the same village ; D, F, I, J and N likewise come from the same village, as do L and P. E is from the middle Marowyni region of the Aucaner tribe. C and M are Bush Negro pieces but the tribe of origin is not known. I is 19" long, and P $27\frac{1}{4}''$.

17. FOOD PADDLES AND CLOTHES BEATER. (AMNH). Note the head at the top of the handle of F. Compare G with C of figure 9, and note the suggestion of a mask in the handle. Compare B with C of figure 9. The clothes beater, D, is a particularly fine specimen and the patina suggests that this is a piece of some age. It is 23" long and the blade is $\frac{3}{4}''$ thick ; its provenance is not known. A and F are from the Aucaner tribe, the latter coming from the Sara Creek district, B and C are from the upper Aucaner, Tapanohoni river. E and G are from the Saramac-

caner tribe, the latter coming from the upper Surinam river region. Lengths: A 19″, E 17¾″, F 16½″, G 19½″.

18. CLOTHES BEATERS. (AMNH). A and C form a most unusual pair. This is the only case the writer has come across of two specimens almost exactly forming a pair, with opposition symmetry when the two pieces are juxtaposed. Further, the designs are unusual and strangely naturalistic. These two beaters are somewhat crudely carved, as is piece B, and suggest influences from the Town Negro. B appears to be charged with sexual symbols, the vulva appearing on handle and blade. Lengths: A 25″, B 23¾″, C 26″. Thickness of blade: A 1½″, B 1¼″, C 1¼″. A and B have rounded blades. They are from the Aucaner tribe.

19. CANOE PADDLES. (AMNH). As as been noted in the text, the designs painted on the blades are supposed to be clan symbols ; they appear on both sides of a blade and differ on each side. These are the only examples of a relatively elaborate use of paint on carvings by the Bush Negro. The colours on A are white, with traces of a vermilion red, black and a green viridian ; on B they are white with traces of a viridian green, black, green, and a vermilion-like red ; on C, black and a deep green, like Hooker's green ; and on D there are traces of an ultramarine blue, black, a permanent green and a medium vermilion-like red. All four paddles are from the upper Aucaner tribe. A is 5′ 3″ long and is 12″ wide at the widest part of the blade ; B 5′ 5¾″, and 10¾″ ; C 5′ 7″ and 13″ ; and D 5′ 4″ and 9″.

20. CANOE PADDLES. (AMNH). B is a most unusual specimen as the blade is of two parts which are separate, being joined only at the roundel where they meet the median section. The second part of the blade is immediately behind the surface visible in the photograph. It is as though the blade had been split down the middle. The carved handle is divided into two parts in the same way. A is from the region of the upper Surinam river, and B from the Aucaner tribe. A is 54½″ long, B is 59″.

21. CANOE PADDLES. (AMNH). A and B are from the Saramaccaner tribe, B coming from the upper Surinam river region. Lengths: A 81½″, B 77¼″.

22. CANOE PADDLES. (PENN). B is a Bush Negro paddle some 4′ in length. It has dots painted on the handle, evidently in imitation of brass tacks. C is evidently a Bush Negro paddle for it has the typical Bush Negro form but its decoration in blackish paint is entirely Indian, as can be seen by comparing it with paddle A, which is Indian in form and in decoration (Carib ?). This

would seem to provide a most interesting example of contact with the Indian tribes who are normally avoided. (Compare plates and figures in Roth, 1924). D is $4\frac{1}{2}'$ long.

23. STOOLS. (AMNH). The seats of both stools are most unusual and particularly striking. A is of formal type B, mentioned in the text, though the snake, decorating one side, with its head projecting, is a feature that has not been encountered by the writer in any other example of stools seen. The motif covering the seat recalls designs decorating certain trays. Note the cowrie shell inlaid at the centre. B is of formal type A. The design, though most striking, is a variation on certain abstract faces and heads that appear now and again in Bush Negro art, as in the case of some architectural forms of decoration where the mask is intentional, though these may be fortuitous cases, as in figures 8C, 9C and 17 G. Interesting in B are the tops of the wedges of the legs which are let into the seat in such a way that they form part of the decorative scheme of that surface. The seat of A is slightly concave. It measures $8\frac{3}{4}'' \times 8\frac{3}{4}''$; the snake is $3\frac{1}{4}''$ wide and $13\frac{1}{4}''$ long. The height of this stool is 9''. The top of B measures $15'' \times 9\frac{1}{2}''$ and the stool is $10\frac{3}{4}''$ high. It comes from the Sara Creek district of the Aucaner tribe.

24. STOOL. (H). The design of the seat should be compared with that of the tray in plate 33B. The top of this stool is approximately $19'' \times 10''$, and some 13'' high. The height of the cross piece is $3\frac{1}{3}''$. The stool is type A mentioned in the text.

25, 26A and B. STOOL. (AMNH). (Top, side and front view respectively). This is a particularly fine specimen and manifests the virtuosity of the artist through its richly but controlled decorated surfaces. The intertwining motif of the seat is like an enlarged version of some motifs that decorate the handles of food paddles. The relationship of all decorated surfaces, seat, legs and cross pieces, is subtley conveyed by the variations on the intertwining motifs employed, stress being given to those surfaces likely to be seen most, namely, seat and cross pieces. The stool is of type A mentioned in the text. A Dutch coin is inlaid at the centre. The provenance is not known. The seat measures $31'' \times 16''$, height $19\frac{3}{4}''$, height of cross piece $10\frac{1}{2}''$.

27. STOOLS. (AMNH). Note the inlaid piece of wood at the centre of B. This stool demonstrates well the alternation of brass tacks and cartridge marks to emphasize the curvilinear flow of the motif of the seat. The top is $25'' \times 11\frac{1}{4}''$ and the stool is $13\frac{1}{4}''$ high. A is from the Upper Surinam river and measures $19\frac{1}{4}'' \times 9\frac{1}{2}''$, and is 13'' high. Both stools are of formal type A

mentioned in the text, but B is exceptional as the cross pieces fill in the sides entirely, as with the circular topped type of stool, type D (diagram V).

28. STOOL. (AMNH). Brass tacks decorate the seat of this crescental stool as well as the feet. The provenance is not known. It measures, direct from crest to crest $19\frac{1}{4}''$; the legs are $6\frac{1}{2}''$ high (to the middle of the crescent edge) and the greatest width of the seat is $9\frac{1}{4}''$.

29. STOOL. (AMNH). The design of the legs of this crescental stool should be compared with that of the peanut pounding board in figure 37B. There is a Bush Negro crescental stool in the Chicago Natural History Museum (Field Museum), No. 191680, which has legs of an almost identical design, the only difference being that the crossings of the curves of the legs are differently placed. The provenance of this stool is not known. It is $26''$ from crest to crest; the greatest width of the seat is $9''$, and the legs are $11\frac{1}{2}''$ high, to the middle of the edge of the crescent.

30 and 31. TRAY, front and back. (H). The design of the front of this tray represents two human couples and a pair of twins. In each of the two halves is a *manu ko muye,* man and woman figure, "so styled that only the limbs are shown. The two smaller outlines near the centre of the outer rim, facing each other, represent the male and female child to be born of the matings, and the Bush Negro artist has distinguished the male child by repeating the line of the inner design of one of the symbols for the children. The breaking up of the rim is also an integral part of the symbolism, for the sections containing the alternating squares represent the hair of the two women, while the cross-hatching represents the hair of the children." (Cf., Herskovits, October, 1930.) Attention has been called in the text to the importance attached to fertility among these peoples; twins are particularly venerated, so that as symbols of fertility in the design of this tray they act in the context of sympathetic magic. The tray measures some $30''$ in diameter, though the exact measurement is not known. (See also 35 below.)

32. TRAY. (AMNH). This tray is from the Boni tribe on the French Guiana side of the lower Marowyni river. Its diameter is $27\frac{1}{4}''$. (See also 35 below.)

33. TRAYS. (AMNH). The design of B is of the same style as the stool in figure 29 and the peanut pounding board in figure 37B. Attention has already been called to the comb B, in figure 3. The diameter of A is $22\frac{1}{2}''$, of B $23\frac{1}{2}''$. (See also 35 below.)

34. TRAYS. (AMNH). The profusion of brass tacks on the inside of A, in the opinion of the writer, rather detracts from the low relief motif. B is from the lower Saramacca river. The diameter of A is 21″, of B 19½″. (See also 35 below.)

35. TRAYS. (AMNH). If the reader turns back to figure 30 through figures 34A, 33A, 32, 31 (back of tray 30) a strong relationship between the major motifs depicted on each tray should be apparent. Knowing the symbolism of the front of the tray depicted in figure 30, it is highly suggestive that the low relief decorations on the other trays are significant in the context of fertility as well as in the field of sympathetic magic. Without Dr. Herskovits' record from the field it would still be possible to hypothecate that the designs on the trays are associated with sex, and possibly procreation, by proceeding in the reverse order, i.e., from figure 35B to figure 30, on evidence of the low relief decoration in the first piece of this series, where two recognisable figures are depicted in an attitude strongly suggestive of some sex act. The ethnographical knowledge of the importance of sex and fertility in this culture would provide a basis for such a hypothesis. The diameter of B is 25½″.

36. PEANUT POUNDING BOARD. (H). The specimen in the plate is standing on end so that two cross pieces forming the legs are not visible. They are at right angles to the main axis of the board, at each end of the uncarved central area. The whole piece is carved from one piece of wood. It is 25¾″ long and 8.8″ wide ; the central section is 10¾″ long.

37. PEANUT POUNDING BOARDS. (AMNH). Compare the design of the legs with those of the stool, figure 29. The pounding surface of A is not square, measuring 13¾″ at one end and 10¼″ at the other. The legs are attached. B is carved out of one piece of wood. The length of the legs of A is 20″. The rim around the pounding surface is 1½″ wide. The height of the legs is 3″. The overall length of B is 23½″. The pounding surface is 13″ x 11″ across, at the middle. The length of the legs is 16″ and their height, to the pounding surface, is 6″. A is from the lower Marowyni river region of the Aucaner tribe. The provenance of B is not known.

38. PEANUT POUNDING BOARDS. (H). The design of the handle of A recalls certain designs found on food paddles. It has no legs, and, as B, is carved from one piece of wood. The pounding surface of A measures 16″ x 10″ across, at the middle. Its handle is 6½″ long and 4½″ across. B is 25½″ long, the pounding surface being 11¼″ x 10¾″ across, at the middle.

39. PEANUT POUNDING BOARD AND POUNDERS. (H). The designs of the handles of A and C, particularly, recall motifs employed to decorate the handles of food paddles. All three specimens in this plate are carved from one piece of wood. The pounders are particularly heavy and perhaps are of iron wood. The length of the handle of the pounding board A is about $6\frac{1}{2}''$ and the diameter of the board is $8\frac{1}{4}''$. B is $15\frac{1}{2}''$ long, the handle being $6\frac{1}{4}''$, and C $11\frac{1}{2}''$, the handle being $3''$.

40 and 41. DRUM. (H). This is an Apinti drum and the type has been discussed in the text. A comparison of the two plates will show how the motif repeats itself around the body of the drum.

42. DRUMS. (AMNH). A is an Apinti drum. B is a Town Negro drum and provides an interesting comparison with those from the Bush, as it is relatively crude and the lashing of the head roughly done. C is a Tumao drum. The motif around the body of A does not repeat itself as on the drum in figs. 40 and 41. It is of the type where the design is as though conceived on a cylinder cut vertically and rolled out flat ; this was discussed in the text. A and C are from the Saramaccaner tribe, the latter coming from the upper Surinam river region. The diameter of the head of A is $10''$, the greatest diameter $11\frac{3}{4}''$, and the diameter of the foot $6\frac{1}{4}''$. The thickness of the wood is about $1\frac{1}{2}''$ and it has 7 pegs. It stands some $18\frac{1}{2}''$ high, the height of the foot being $2\frac{1}{4}''$. The diameter of the head of C is $9\frac{1}{2}''$, of the foot $7\frac{1}{2}''$. The thickness of the wood is about $1''$ and there are 5 pegs. It stands some $21\frac{1}{2}''$ high. B, the Town Negro drum, has a diameter at the head of $5\frac{3}{4}''$, at the base $5\frac{1}{2}''$. Its average thickness is $\frac{3}{4}''$ and it is $19''$ high.

43. OBEIAH IMAGES. (AMNH). A1 and B1 are front views ; A2 and B2 are profile views. Note the vertical lines on the trunks of A and B ; B does not have the dots, circle and horseshoe shape to be seen on the trunk of A2. Refer to the section on Religious Images in the text for further discussion. A is $24\frac{3}{4}''$ high, B $25''$. The diameter of the cylindrical form of A is $3\frac{3}{4}''$, of B $4''$. The height of the head of A and B is $3\frac{3}{4}''$, of the neck of both $2\frac{1}{2}''$. The provenance of these specimens is not known.

44. RELIGIOUS IMAGE. (AMNH). Notes made by Kahn in the catalogue of the American Museum of Natural History designate this image as the god *Aflamu,* who protects the village from the evil spirit folk of the jungle. " Spirits are supposed to be negroes who can at will change into tree stumps or bush vines

and in this form can see and shoot without exposing themselves to counter attack." This image may have a strong æsthetic appeal to certain observers. It should be noted, however, that its formal qualities are alien to those of other Bush Negro carving and the æsthetic qualities not in conformity with the general æsthetic qualities engendered by those other carvings. It is made of very heavy wood. It is 32″ in length, 5″ wide at the shoulders ; the arms are 6″ long. The head is 6″ long by 4½″ wide. The neck is 2″ long. The trunk is 16″ long and the legs, including the " pelvis " 8″. The width at the bottom of the pelvis is 5″. The legs are 4¾″ long.

45. RELIGIOUS IMAGE. (YALE). This image represents a god named *Kundi*. A screw has been used to hold the conventionalized arms of this image in place for photographing. They were probably kept in position by a nail. The thick piece of wood forming the arms is backed by a thin piece of three-ply wood. It may well be that the arms were slightly hollowed out, some magical substance introduced, and then covered by the three-ply. The thicker piece of wood is nearly 1″ thick. The conventionalized hands are ½″ thick and measure 2″ x 5″ x 1″. The greatest width of the arms is 17″. The height of an arm is 7¼″. The image stands some 20″ high, without the base, which has been turned and is evidently not of Bush Negro manufacture. The height of the head is 3″, the neck 2″, and the height from the foot to the arms is 10″. The diameter of the cylindrical form of the image is about 4″. The image is from the Commewyne river region of the Boni tribe.

46. FANS. (PENN). The provenance of these fans is not known, save that they were collected in Dutch Guiana. They may be Indian work for they are similar to Arawak fans shown by Roth (Cf. Plate 78, Roth, 1924). Bush Negro fans of identical form have been seen in the Herskovits' collection. (Not wood ; materials unknown.)

47. BASKETRY. (AMNH). A seems like African work while B and C are similar to Indian specimens, all three, however, are from the Bush Negro. C is a sifter for cassava flour. A is unfinished. The diameter of its base is about 10¾″ ; its average depth 5″. B is 12″ long and 7″ wide, and has an average depth of 6½″. C is 11½″ x 10½″ and has a depth of 3″. A and B are from the upper Surinam river region of the Saramaccaner tribe. C is from the Sara Creek district of the Aucaner tribe. (Not wood ; materials unknown.)

48. SIFTERS FOR CASSAVA FLOUR. (PENN). **The provenance of** these specimens is not known and they may be Indian work. They are, however, like Bush Negro examples of cassava flour sifters. (Not wood ; materials unknown.)

49. CALABASH CONTAINERS. (AMNH). These two specimens were carved by men, the former by a boy of eleven years; the interiors are not carved. The designs are from the design range used by the men. Compare the design of A with that around the door of figure 52. Contrast these two calabashes with those in figures 50 and 51, which are carved by women, and on the inside surface only. B is the bottom of a carved calabash water tight container. A and B come from the upper Surinam river region of the Saramaccaner tribe. A has a diameter of 8″, B of 7½″. Both are 5″ deep. (Material : calabash.)

50. CALABASH CONTAINERS. (AMNH). These three calabashes were carved by women on the inside only. Note the difference in designing and of the motifs used to those of the men, as referred to in the text. A is 7¼″ long, B 10¾″, C 7½″. A and C come from the same village in the upper Surinam river region of the Saramaccaner tribe. B is from the lower Marowyni river region of the Aucaner tribe. (Material : calabash.)

51. CALABASH PLATES. (AMNH). Refer to notes of figure 50. The motif decorating the interior of B is called a bone motif. Both specimens are from the same village of the upper Surinam river region of the Saramaccaner tribe. A measures 10″ x 9¾″, and B 9¼″ x 8½″. (Material : calabash.)

52. DOOR. (AMNH). Four carved planks, 1″ thick, form the door frame ; they are joined by strips of metal which are nailed on. The low relief motif on these planks is ¼″ deep. Compare this motif with that on the calabash, figure 49A. The outer measurements of the frame are 52¼″ x 37″. The door is set back from the frame to a depth of 5¾″, and opens inward. It measures 25¾″ x 40¾″. From an examination of the door it looks as though it may have been made from one piece of wood, which had split into three vertical sections, each of which contains a row of the three rows of pierced motifs that form the door. It may well be, however, that each row was carved from one plank and then the three fitted together, for the Bush Negro are skilful joiners. In the centre of the door is a round knobbed handle, protruding some 3¾″. The wood of the door section is about ¾″ thick. The specimen comes from the upper Surinam river region of the Saramaccaner tribe.

Printed by Suttons, Paignton

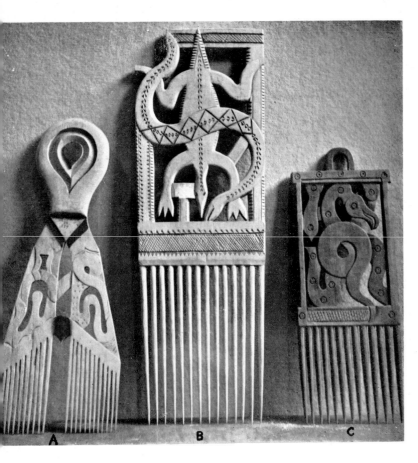

1. Combs. Aucaner tribe.

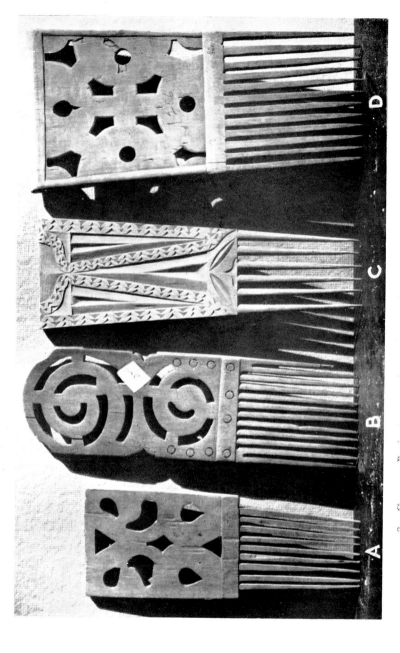

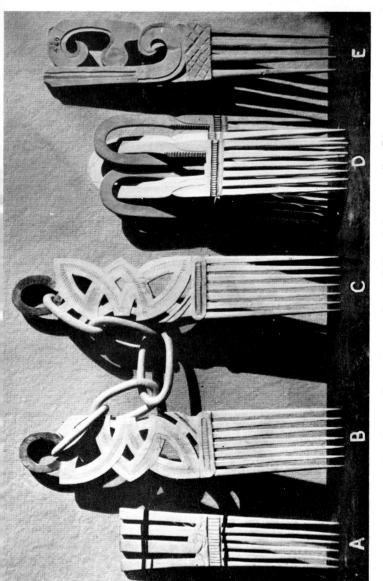

3. Combs. Saramaccaner tribe (A,B,C) and Aucaner tribe (D).

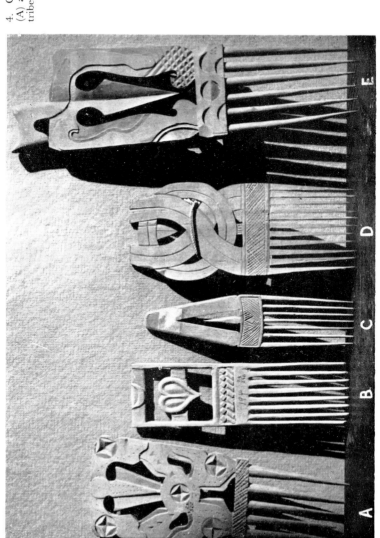

4. Combs. Boni tribe (A) and Saramaccaner tribe (B-E).

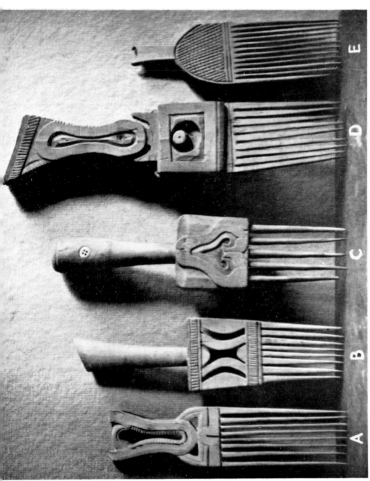

5. COMBS. Saramaccaner tribe (A,B), Aucaner tribe (C), lower Saramaccaner river (D) and upper Surinam river (E).

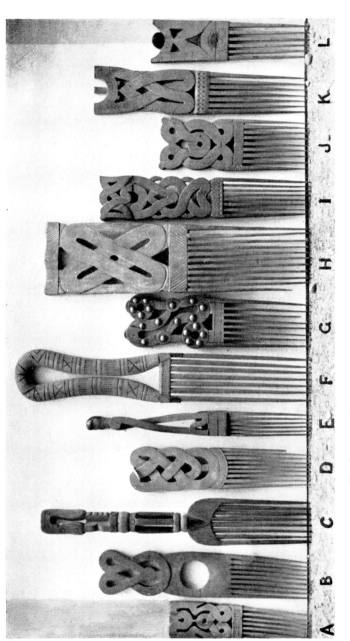

6. COMBS. Saramaccaner tribe (C,E and G not confirmed).

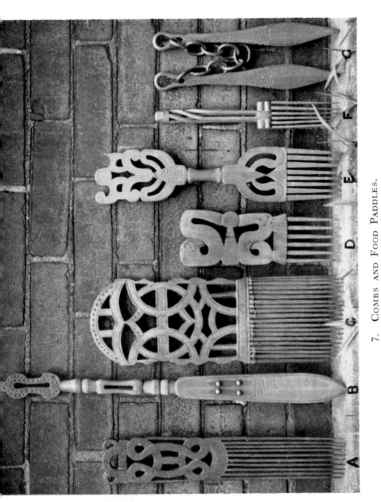

7. COMBS AND FOOD PADDLES.

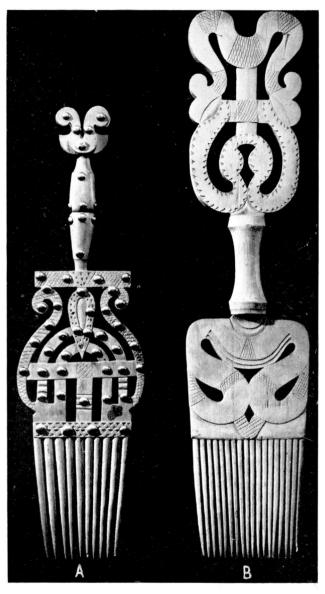

8. COMBS. Saramaccaner tribe (A) and Aucaner tribe (B).

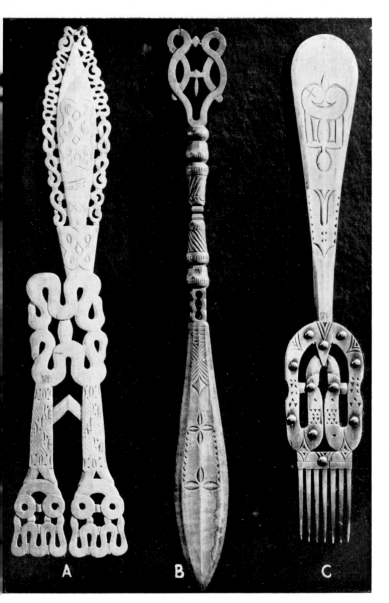

9. FOOD PADDLES. Aucaner tribe (A,C) and Saramaccaner tribe (B).

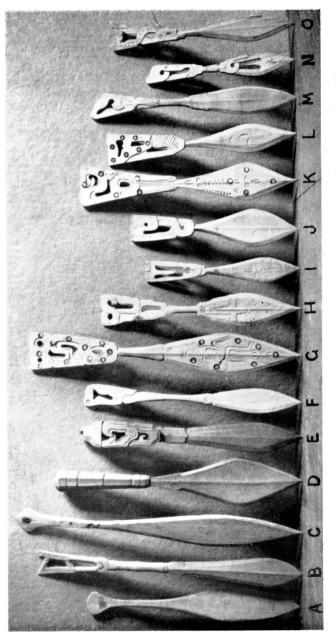

10. Food Paddles. Saramaccaner tribe (A,B,C), Aucaner tribe (D-N) and Paramacca tribe (O).

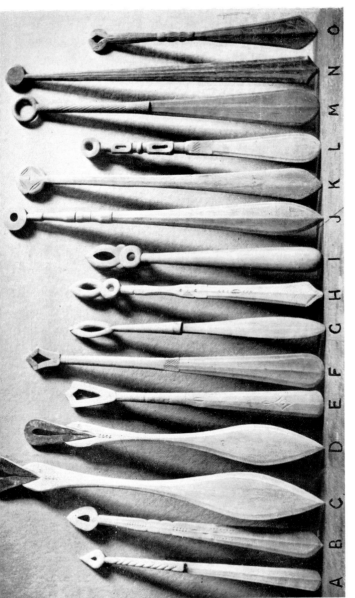

11. Food Paddles. Saramaccaner tribe (A-C, E-N) and Boni tribe (O).

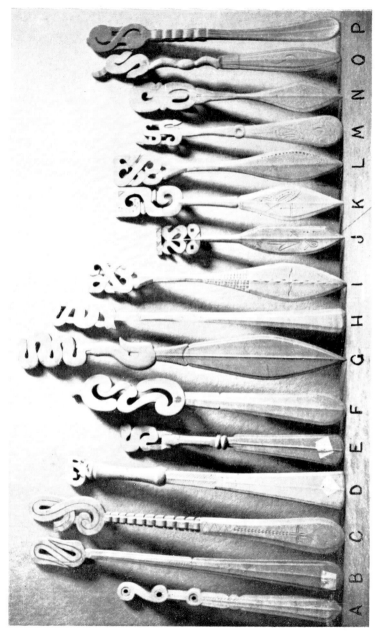

A B C D E F G H I J K L M N O P

12. FOOD PUSHERS. SCRAPER-PUSHERS (A, E, G, M). A PESTLE-PUSHER (H, I, J, K, L, N). (A, S IS A SCRAPER-PUSHER (T, F)

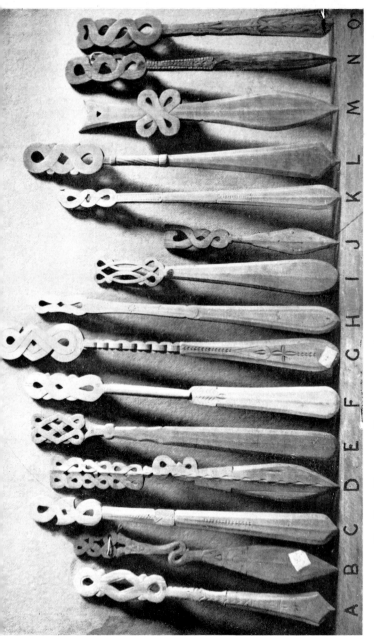

13. Food Paddles. Saramaccaner tribe (A,C, E-H, K-O), and Aucaner tribe (B,J).

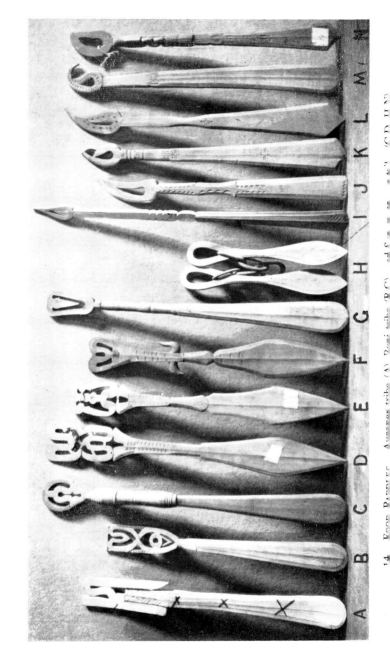

14. FOOD PADDLES. Awayara tribe (A). Rossi tribe (B,C), ... (D,E,...,...). (F,...,...,...). (CD,H,N)

A B C D E F G H I J K L M N

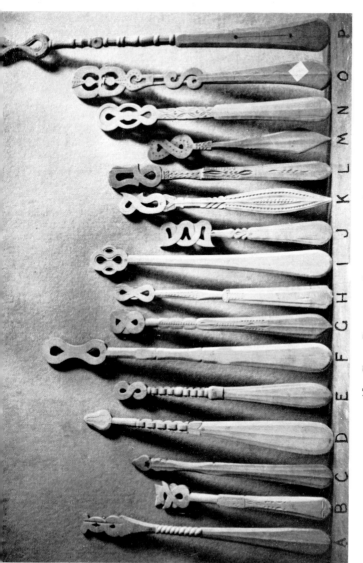

15. Food Paddles. Saramaccaner tribe.

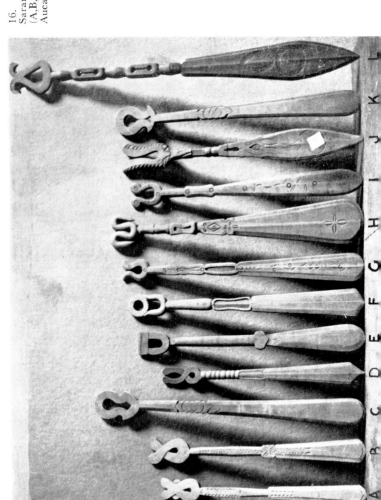

16. Food Paddles. Saranaccaner tribe (A,B,D,F-L,N-P) and Aucaner tribe (E).

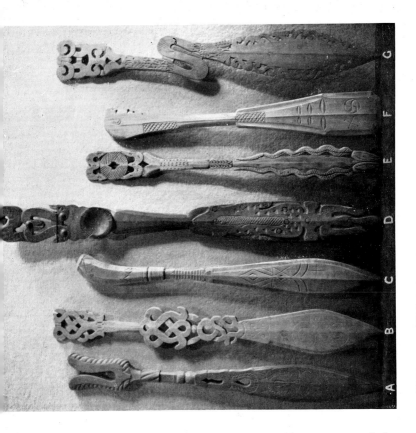

17. FOOD PADDLES AND CLOTHES BEATER. Aucaner tribe (A,B,C,F), and Saramaccaner tribe (E,G).

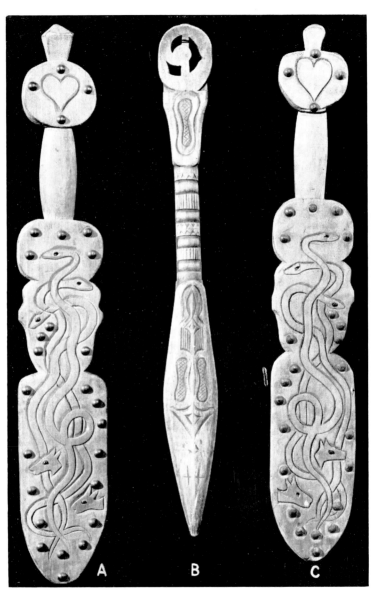

18. CLOTHES BEATERS. Aucaner tribe.

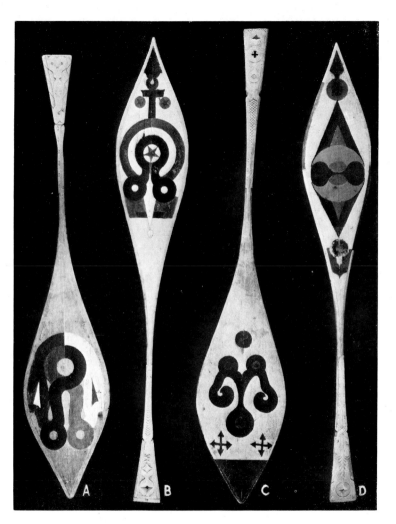

19. CANOE PADDLES. Aucaner tribe.

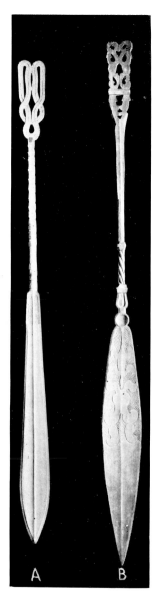

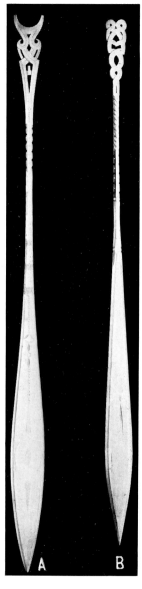

20. CANOE PADDLES.
Upper Surinam river (A)
and Aucaner tribe (B).

21. CANOE PADDLES.
Saramaccaner tribe.

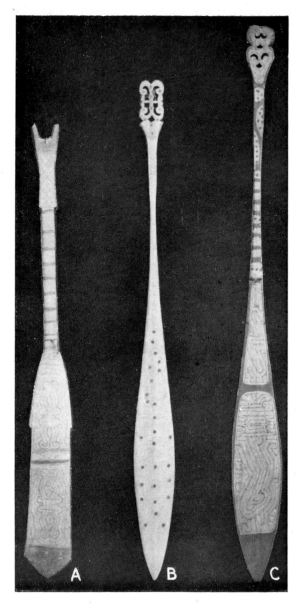

22. Canoe Paddles.

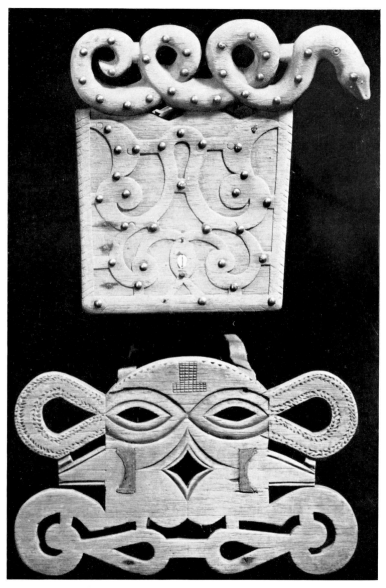

23. STOOLS. Aucaner tribe.

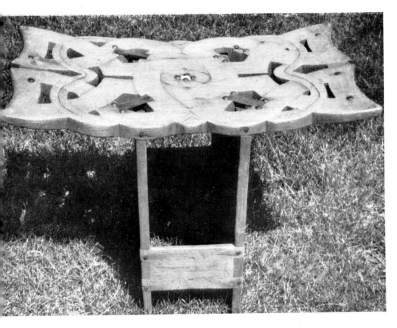

24. STOOL.

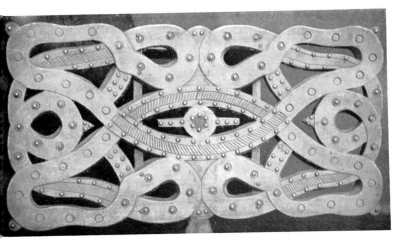

25. STOOL.

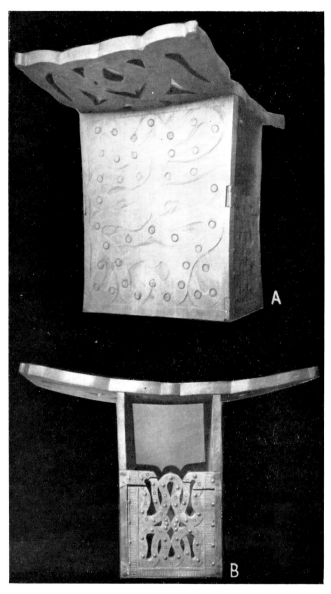

26. Stool.

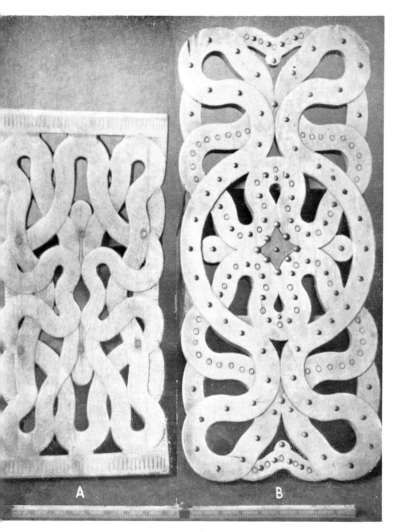

27. STOOLS. A is from the upper Surinam river.

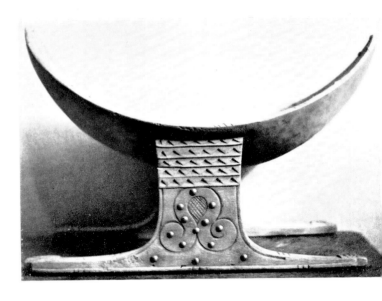

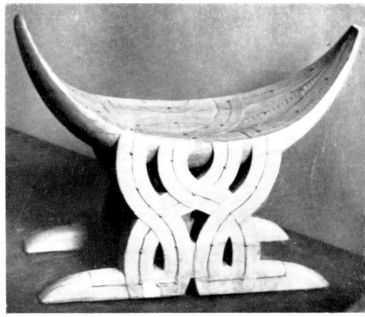

28, 29. STOOLS.

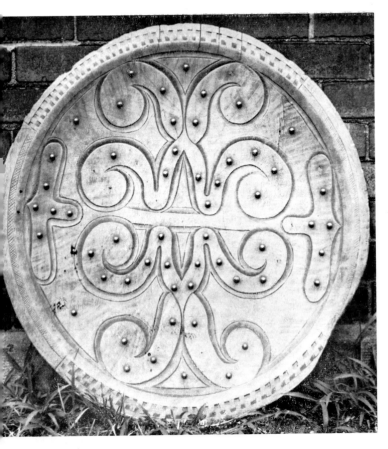

30. TRAY.

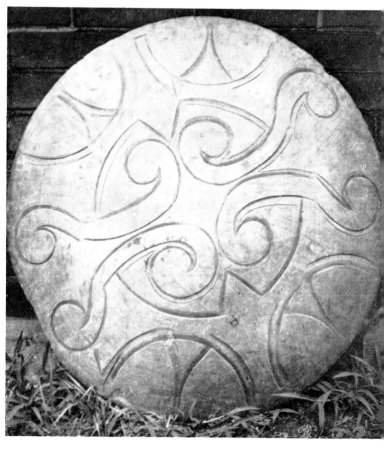

31. TRAY (back of fig. 30).

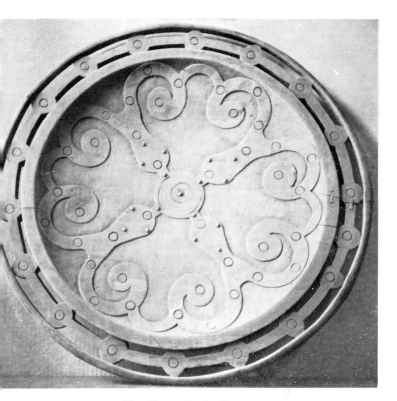

32.　Tray.　Boni tribe.

33. TRAYS.

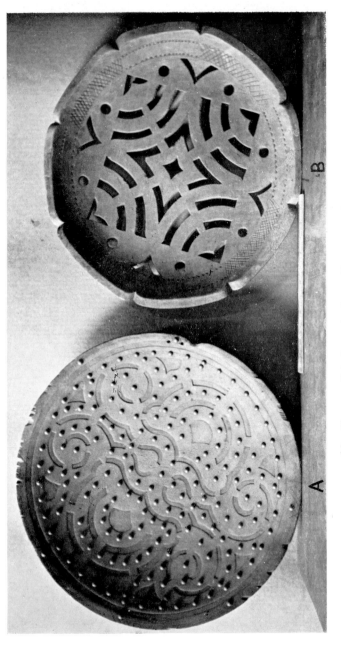

34. TRAYS. B is from the lower Saramacca river.

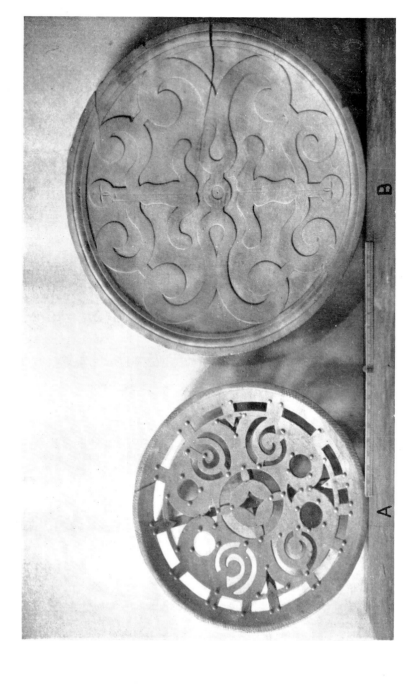

A B

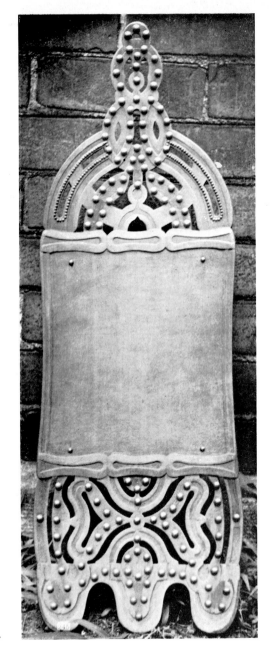

36. PEANUT
POUNDING BOARD.

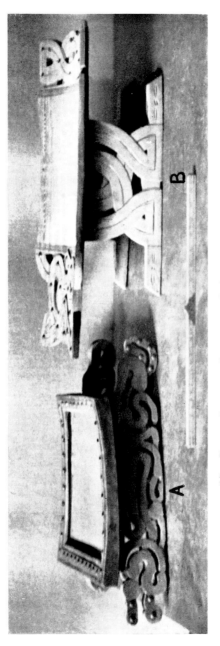

37. PEANUT POUNDING BOARDS. A is from the Aucaner tribe.

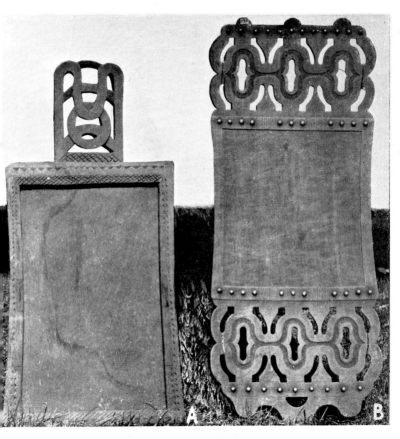

38. Peanut Pounding Boards.

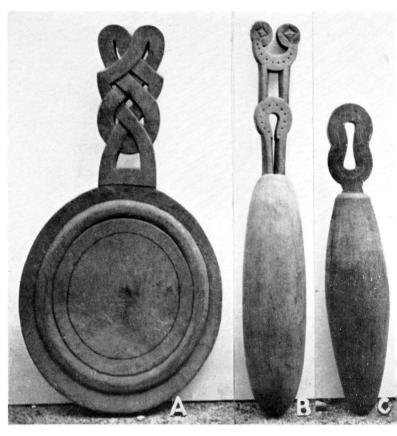

39. PEANUT POUNDING BOARD AND POUNDERS.

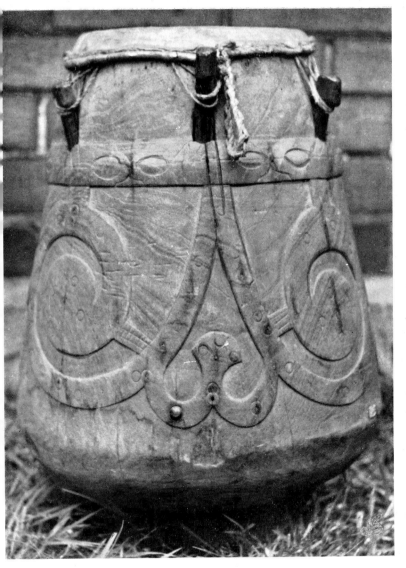

40. Apinti Drum.

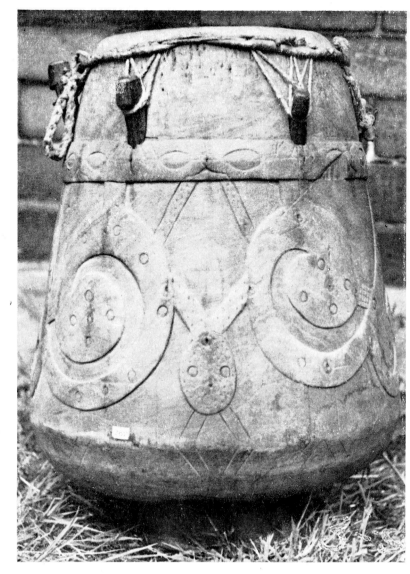

41. Apinti Drum.

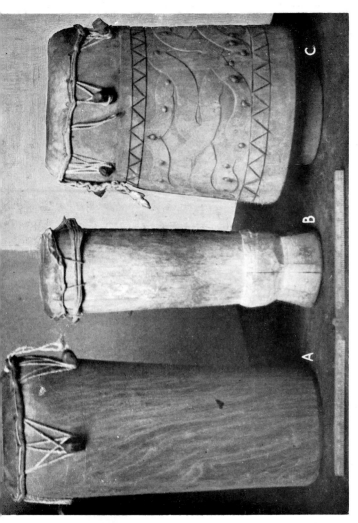

42. Apinti Drum (A), Town Negro Drum (B), and Tumao (C). A and C Saramaccaner tribe.

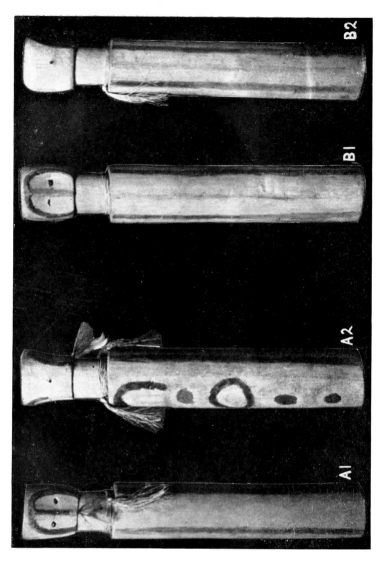

43. OBEIAH IMAGES.

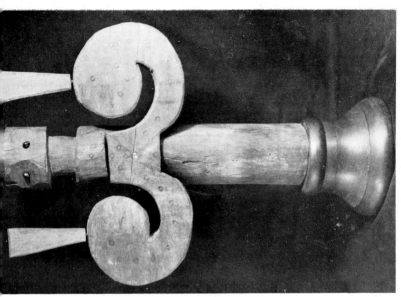

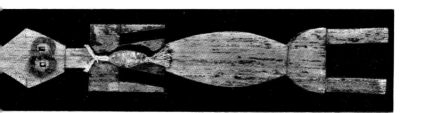

45. RELIGIOUS IMAGE.
Boni Tribe.

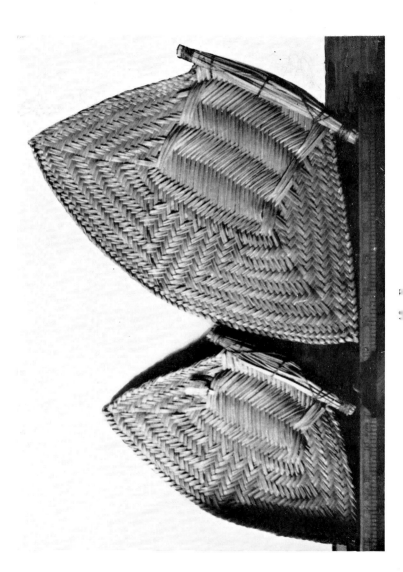

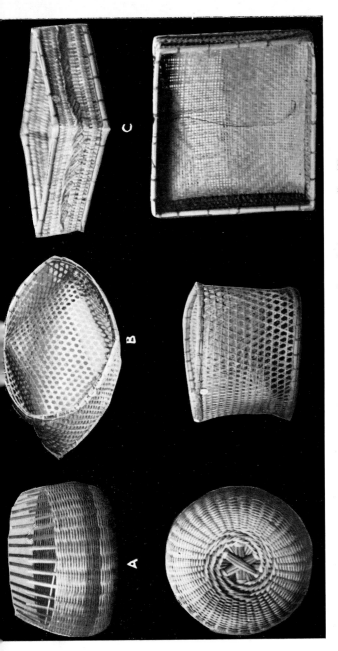

47. BASKETRY. Saramaccaner tribe (A,B) and Aucaner tribe (C).

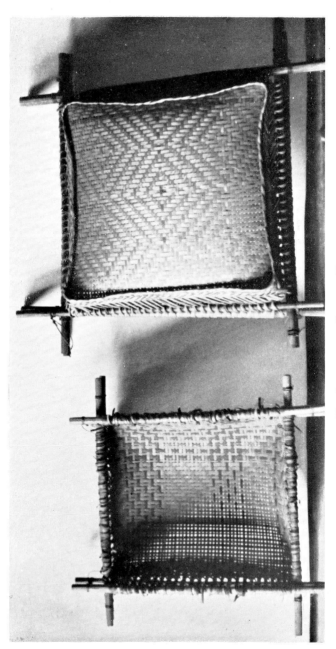

48. Sifters for Cassava Flour.

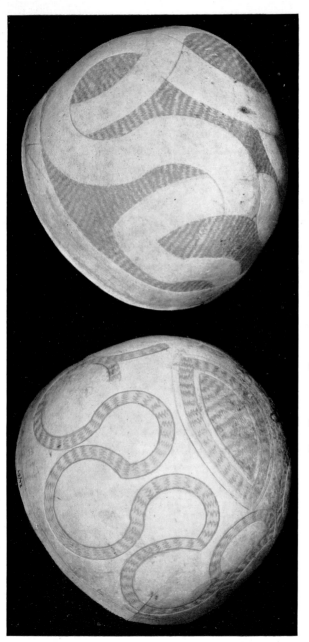

49. CALABASH CONTAINERS. Saramaccaner tribe.

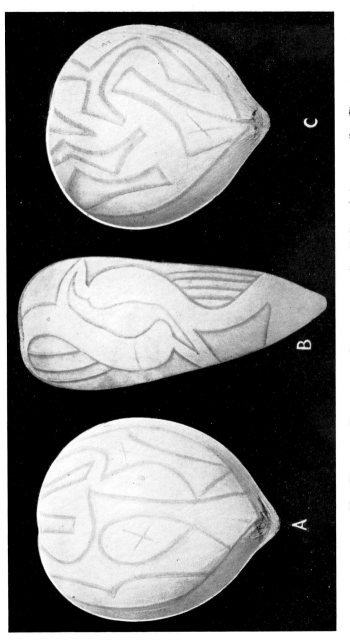

50. CALABASH CONTAINERS. Saramaccaner tribe (A,C) and Aucaner tribe (B).

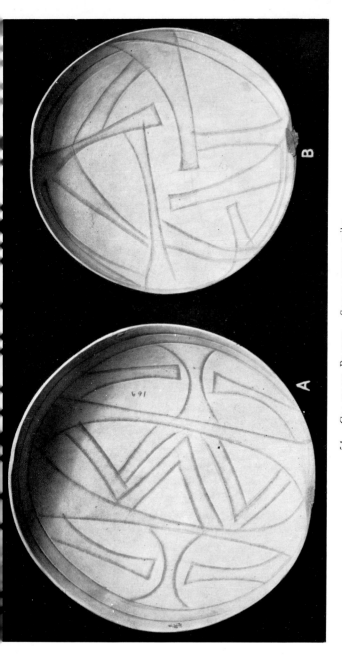

51. CALABASH PLATES. Saramaccaner tribe.

52. DOOR. Saramaccaner tribe.